GERTRUDE JEKYLL

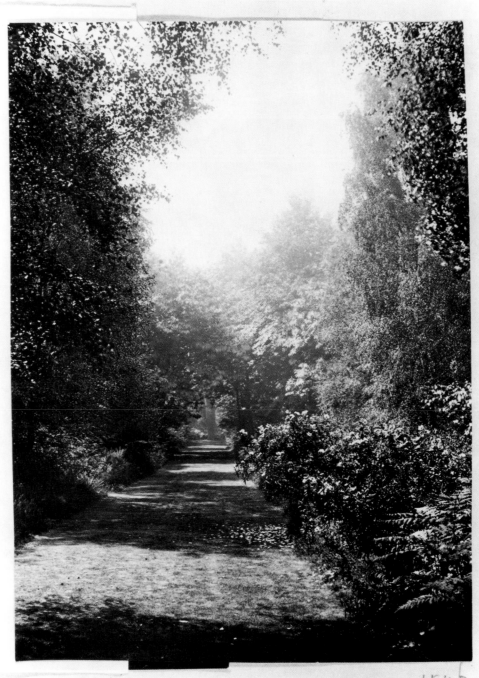

1546

GERTRUDE JEKYLL

A Vision of Garden and Wood

JUDITH B. TANKARD

MICHAEL R. VAN VALKENBURGH

FOREWORD BY JANE BROWN

A Ngaere Macray Book

HARRY N. ABRAMS, INC. / SAGAPRESS, INC.

NEW YORK

An exhibition entitled "Gertrude Jekyll: A Vision of Garden and Wood" has been made possible by the Art Program of Bank of Boston and is scheduled to be shown at the following locations:

Bank of Boston Gallery, Boston
9 June–15 August 1988

Smith College Museum of Art, Northampton, MA.
13 September–16 October 1988

Dallas Arboretum, Dallas
27 October–20 November 1988

PaineWebber Gallery, New York City
16 February–5 May 1989

After traveling in the United States the exhibition will become a permanent installation at Bank of Boston World Banking Group International, London.

Photographs © The College of Environmental Design Documents Collection, University of California, Berkeley.

Library of Congress Cataloging-in-Publication Data

Tankard, Judith B.
Gertrude Jekyll: a vision of garden and wood / Judith
B. Tankard and Michael R. Van Valkenburgh; photographs
by Gertrude Jekyll; foreword by Jane Brown.
p. cm.
Published in conjunction with a major exhibition of Gertrude Jekyll's photographs. Bibliography: p.
Includes Index.
ISBN 0–8109–1158–2
1. Munstead Wood Gardens (England)—Pictorial works. 2. Gardens—England—Design. 3. Jekyll,
Gertrude, 1843–1932. I. Tankard, Judith. II. Van Valkenburgh, Michael. III. Title
SB466.G75E578 1989
712'.092'4—dc19 88–13896

Edited by Barbara Probst Morrow
Design and composition by The Sarabande Press
Production Coordinated by Doreen Ralph
Printed in the United States by Kingsport Press
First Printing

FRONTISPIECE. "CISTUS BY THE WOOD-PATH" · A vista from the house down the green wood path ends with a Scotch fir that stood on Jekyll's property when she acquired it in the 1880's.

CONTENTS

ACKNOWLEDGMENTS

A visual documentation of the lifework of Gertrude Jekyll, as portrayed in her personal photograph albums, has been made available to the public in a traveling exhibition entitled "Gertrude Jekyll: A Vision of Garden and Wood," generously sponsored by the Art Program of Bank of Boston. The publication of a companion book, which further studies Jekyll's important role of designer as revealed in her own photographs, would not have been possible without the assistance of a number of individuals and institutions. Partial funding for this book has been provided by the Romill Foundation, Owen Larkin in memory of his wife Patricia Larkin, John and Anne Tankard, and Hall and Kate Peterson. Additional support has been received from PaineWebber, Brooklyn Botanical Garden, Smith College, the Dallas Arboretum, the Graduate School of Design Harvard University, and other institutions. Research for Michael R. Van Valkenburgh's essay, portions of which were originally published in *Design Quarterly 137* (Autumn 1987), was supported by the Design Arts Program of the National Endowment for the Arts and the Graham Foundation for Advanced Studies in the Fine Arts.

A number of individuals have been consulted in the research for the exhibition and the book, most notably Primrose Arnander, who supplied information about Jekyll family history, and Michael Tooley, who shared his extensive research on Gertrude Jekyll and Munstead Wood. Lady Clark was generous of her time and support, and in addition, Jane Brown, Mavis Batey, Diane Kostial McGuire, and Margaret Richardson provided critical information.

The photographs in this book were selected from Gertrude Jekyll's notebooks and are reproduced with the kind permission of the College of Environmental Design Documents Collection, University of California, Berkeley. Margaret Wong, Caitlin King, and Dianne Harris from the staff of the Documents Collection assisted with the details of their preparation. They were printed by Jack Ramsdale, a professional photograper based in Philadelphia, from negatives that were made directly from Jekyll's photo-notebooks.

The composite plan of Munstead Wood was drawn by Kate Collins and Dodie Finlayson, students at the Graduate School of Design Harvard University, and Marsha Topham, a Boston architect.

Special thanks go to Mildred Friedman, editor of *Design Quarterly*, and Lorraine Ferguson, the designer of *Design Quarterly 137*, who brought the authors together while preparing an issue entitled "The Flower Gardens of Gertrude Jekyll and Their Twentieth-Century Transformations."

Judith B. Tankard
Michael R. Van Valkenburgh

FOREWORD

Jane Brown

Miss Jekyll's star has now risen for the third time within a century: during the 1870's and 1880's she was admired as a painter and craftswoman by a wide circle of friends, and then she became famous as a gardener and garden designer in the years before the outbreak of war in 1914. During the 1970's and 1980's she has steadily risen to her rightful place as the most important influence of all on twentieth-century gardeners.

Modern gardeners pursue a catholic art: the perfect lawn, largest tomatoes, or brightest pelargoniums are no longer their goal. Garden making is now a subtle blending of inspirations held in common with painters, writers, interior decorators, flower arrangers, gourmets and herbalists, embroiderers and photographers. The remarkable thing is that at some time in her ninety years, Gertrude Jekyll was all of these. She really is the fount of all our modern philosophy in planting design, gardening, and place-making, and more than enough ideas for one ordinary lifetime can be found in her practical prose and in her artist's vision of her garden.

There are two further historical reasons for Jekyll's arrival at the eminent place she holds among garden designers today. First, she has been brought into focus in the eyes of design professionals by the rediscovery of the work of Edwin Lutyens. She met Lutyens when he was just twenty years old; when he died, on New Year's Day 1944, he was mourned as "the greatest English architect since Sir Christopher Wren." But, within a few years, really marked by the publication of Country Life's massive four volume *Memorial* in 1950, he was eulogised into a remoteness, grandly irrelevant to architects and designers coping with the postwar world.

The Lutyens revival, instigated on both sides of the Atlantic, began in the late 1960's, and culminated in the Arts Council of Great Britain's Lutyens Exhibition, held in London for three months in the winter of 1981–82. This exhibition made him the most well known architect since Wren. Throughout the galleries, as through his life, Miss Jekyll's (whom he called "Aunt Bumps") gardens, her influence and friendship were

strongly present. That such a recognisably great architect as Lutyens should place such high regard on the close relationship between a house and its garden was a point not lost on architects, and it warmed many a landscape architect's heart! The essay on Gertrude Jekyll's design philosophy contributed by noted landscape architect Michael Van Valkenburgh and Carol Doyle Van Valkenburgh is an accolade to this cause.

The second reason for Miss Jekyll's eminence is the preservation and availability of such a vast store of detailed design material in her garden plans and photographs at the University of California at Berkeley. Hardly anyone in England had realised that this treasure survived at all, until Miss Jekyll's biographer, the late Betty Massingham, visited the collection in 1978. Since then the Documents Collection, and especially Professor Stephen Tobriner, have been generous and patient with our enquiries. Now, thanks to Mavis Batey of The Garden History Society, we have two microfiche of the drawings in London, and a steady stream of owners, students, and historians are rediscovering Jekyll gardens and reviving them. The list of restorations—including Hestercombe and Barrington Court in Somerset, Upton Grey Manor House and Marsh Court in Hampshire, King Edward VII Sanatorium in Sussex—continues to grow.

But there were still only a few of us who had seen the six albums of her photographs that include pictures of her own garden at Munstead Wood. The authors' selection of 84 photographs from these albums will fulfill my hope that they could be seen by more of her devotees. I know that Judith Tankard's carefully researched contributions to this book will be received with a special gratitude and great pleasure. As she says, at the beginning of "The Seasons of Munstead Wood," these photographs are part of the "extraordinary record" of Gertrude Jekyll's own garden. If the day comes, and I am sure it will, for the revival of the garden at Munstead Wood this book will play an invaluable part.

August 1988

GERTRUDE JEKYLL

GERTRUDE JEKYLL'S
VISION OF GARDEN AND WOOD

Judith B. Tankard

Gertrude Jekyll (1843–1932) was one of England's foremost garden designers whose concepts still remain inspirational in both England and the United States. She designed hundreds of gardens from 1883 to 1932 for a variety of clients, including both friends and those who contacted her as the result of reading her books and articles. Her innovative style of garden design appealed to many architects as well. Although at least fifty architects consulted her at one time or another, her most exceptional designs represent a collaboration with the architect Sir Edwin Lutyens (1869–1944). Undoubtedly one of their most significant collaborations was Jekyll's own house and garden at Munstead Wood, in Surrey. It was here that she gardened for fifty years and initiated many planting and design ideas that were later applied in design commissions for clients, and where she took numerous photographs that documented these ideas.

When she was in her forties and suffering from deteriorating eyesight, Jekyll was forced to abandon landscape painting and some of the intricate craft work that she had been skillfully practicing for a number of years. Seemingly undaunted by the necessity of having to limit several major interests, she was able to incorporate them in what she would develop as her most significant talent: garden design. By applying her painterly vision and design skills as an artist in the garden, Jekyll was able to implement color and design theories that have rarely been surpassed today. The full-time pursuit of this art would occupy her for the remainder of her life.

Jekyll was a very well established horticulturist and garden designer by the time she met Lutyens in May 1889. She already had a noteworthy garden at Munstead House, where she lived with her mother and worked prior to moving to Munstead Wood. In 1883 she purchased the additional property known as

Munstead Wood across the road and proceeded to develop further gardens there, most notably woodland gardens set among a series of paths. Here she gained experience in developing her special style of gardening.

The garden design and plant-breeding work that she undertook won her recognition among the leading gardeners and horticulturists of the day. One of those admirers was William Robinson (1838–1935), with whom she developed a long-standing professional relationship. Robinson, who was instrumental in rejecting garden designs that were based primarily on bedding-out plants or exotic plant introductions that were then popular, helped to popularize in their place wild and woodland gardens, a concept that Jekyll further explored. Based on her experience in planting design and experimentation at Munstead House and the early years at Munstead Wood, she undertook design commissions for friends and began to publish gardening articles, illustrated with engravings of some of her photographs, in Robinson's weekly *The Garden,* for which she later became an editor.

Jekyll was a multi-talented woman who not only was an extraordinary garden designer and an engaging writer but also was an equally devoted preservationist who sought to record vanishing rural arts and landscapes. In a birthday tribute written in 1926, Lord Riddell described her well: "She brilliantly represents a noble class—women who have a passion for doing useful things as well as they can be done, and who combine feminine sympathies with a masculine intellect and a sagacious outlook."[1]

In 1885 she took up photography, which enabled her to bring together a number of interests.[2] After she quickly mastered the cumbersome process and set up a dark room at Munstead House, she set out to record those elements indigenous to her native Surrey that were rapidly disappearing. She was fascinated by cottage gardens and their cottagers, and by the special construction trades that gave ordinary rural buildings their local character. In addition to these vernacular traditions, she also photographed her own garden as well as specific plants and tree forms, garden design elements, and the local landscape. Gertrude Jekyll's favorite brother, Sir Herbert Jekyll (1846–1932), who shared many interests and friends with her, was an art patron and engineer as well as an amateur photographer.[3] He assembled several carefully labeled family photograph albums and was interested in the preservation of rural buildings, so it is possible that he taught her the art of photography. Jekyll kept prints of most of her photographs in a series of personal photograph albums similar to her brother's. Gertrude Jekyll's earliest attempts at photographing and processing were closely supervised by her instructor, as the back of some of the earliest prints are critiqued in a handwriting different from her own. Some are marked "little over exposed," "bad light," "more pyro—more bromide," and "keep the camera level."[4]

Starting in 1899, with the publication of *Wood and Garden*, Jekyll used her photographs to illustrate

her books, probably using a stock of photographs she had already taken. After the publication of her first two books by Longmans, Green and Company, Jekyll changed to Country Life as her publisher. In the late 1890's she met the publisher Edward Hudson, who championed the work of Edwin Lutyens in the pages of his magazine *Country Life,* which he started in 1897. Around 1900 Country Life embarked on an active book-publishing enterprise, and the first of eight titles by Jekyll appeared in 1901. It is at this point that the appearance of the prints in Jekyll's photo-notebooks changed. A different paper stock was used and in general the printing took on a more professional look, suggesting that Jekyll provided the glass plate negatives for her books and Country Life did the processing. Country Life, of course, was known for the excellence of its photography and printing quality, so quite possibly it was an exception that they allowed Jekyll to provide her own illustrations.[5] A second change that occurred at this time was that as Jekyll began to publish books on a regular basis, she now regarded each book that she illustrated as a photo assignment, and took groups of photographs together.

It is not known precisely how many photo-notebooks Jekyll may have had in her lifetime, as some of her personal effects were bequeathed to her family and are private material. However a group of six albums was sold at auction on September 1, 1948, along with the furnishings of her estate as well as her books, sheet music, watercolor sketchbooks, and paintings.[6] These six albums were later purchased for £18 for the Reef Point Gardens Library in Bar Harbor, Maine, a landscape study center established by the American landscape architect Beatrix Farrand, and were donated to the University of California in Berkeley at 1955 by Farrand's friend and client, Agnes Milliken.[7] Beatrix Farrand (1872–1959), who was a leading landscape architect in America, was a longtime admirer of Gertrude Jekyll. In 1948, after many years of acquiring antiquarian books for Mildred Bliss, her friend and client at Dumbarton Oaks, in Washington, D.C., she was able to write of her "good fortune" at being able to acquire for herself an extensive collection of Gertrude Jekyll's landscape plans and client correspondence that was being sold by the Massachusetts Horticultural Society.[8] After cataloging and extensive restoration work, Farrand donated these plans and letters to the University of California at Berkeley in 1955 when she dissolved Reef Point Gardens. Together with the six photo-notebooks they are known as the Gertrude Jekyll Collection.

It is these six Berkeley photo-notebooks that have provided the visual information for this book and an exhibition entitled "Gertrude Jekyll: A Vision of Garden and Wood." The albums contain 2,151 images that are arranged chronologically, from her first attempts in 1885 to her last photograph, dated August 14, 1914, not surprisingly of her main flower border at Munstead Wood. Three additional albums, which were not included in the auction and are privately owned, include paste-ups of articles written for *Gardening*

Illustrated and *Country Life*, illustrated with photographs of the gardens at Munstead Wood. The clippings in these albums are interspersed with a few photographs with later, penciled-in captions, including one of her pony, who died in 1928, the last recorded date in any of her albums. An inscription in one of the three late albums notes that the photographs in these magazine articles were taken by Herbert Cowley, editor of *The Garden* and *Gardening Illustrated*. Although these albums are undated, most of the articles date from 1918 on. In 1918 Jekyll was seventy-five years old, nearly blind, and quite stout, so it is conceivable that at some point after 1914 she ceased to photograph for publication and had someone else do the work.

In the early volumes of the Berkeley photo-notebooks, Jekyll sometimes overlaid multiple exposures one on top of the other in the album pages, or occasionally overlapped several different angles of the same subject as if to make a more complete picture. For example, the left edge of Photograph 27 shows a similar view underneath the photograph. The right and top edges of Photograph 39 show a similar condition. As a novice photographer, Jekyll took many different views of the same subject matter. Jekyll's method of placing the photographs in the albums clearly shows in some cases the sequencing of shots in a photo session. In Photograph 7, the lefthand edge of the print shows another photograph under it, in this case Photograph 57, taken on the same day in a group with Photograph 11 and Photograph 15. The housekeeper is wearing identical clothing in each photograph, with the storage folds in the apron the crispest in Photograph 7. The subject matter in the early volumes ranges from plant studies (Photograph 53), cottage gardens (Photograph 58), and local monuments (Photograph 56), to studies of trees and landscapes (Photograph 71), rural villages and buildings (Photograph 69), and portraits of friends and commissions (Photographs 46 and 47). In the later volumes, as she further defined her interests, she concentrated on her own garden and subjects chosen for a particular book.[9] It is these later photographs that are more familiar and form an invaluable document of her work. The earlier photographs, however, are generally unfamiliar and provide many clues to her development as a designer and an author.

Beginning in Album 2 (1886), Jekyll took a series of plant portraits that are marked "EFG." These photographs represent her first photo assignment—providing illustrations for a new edition of William Robinson's popular book, *The English Flower Garden*, which was first published in 1883. Engravings of some of Jekyll's photographs appeared in the second edition of 1889 and many subsequent editions, as well as in Robinson's magazine *The Garden*. Photographs used in other books, such as Jekyll and Edward Mawley's *Roses for English Gardens*, are noted in the margins.

The photographs that Jekyll took of rural traditions and vernacular architecture in the early albums are some of the most illuminating for studying Jekyll's many interests, a subject that has not been properly addressed before.[10] The photographs, for instance, show the extent to which Jekyll traveled to take her pictures. Although most of the locations are her nearby Surrey villages, she did travel as far as Yorkshire,

where she took an interesting series of studies of a manor house, and Switzerland, where she spent her vacations with her friends the Blumenthals at The Chalet. In addition, she documented the existing conditions of Robinson's home, Gravetye Manor, when he purchased the property in 1888.

Jekyll's pursuits in landscape painting and craft work, unfortunately, are not too well recorded in her albums. Her workshop at Munstead House (Photograph 44), its cabinets filled with samples and tools, shows the scope of her talents and interests: painting, pottery collections, and wood-inlay work. A detail of one of her repoussé metal pieces (Photograph 45) gives us only a small record of what must have been a prodigious output. Interior decoration commissions, which were plentiful as the result of Herbert Jekyll's friendships with the Duke of Westminster and Edward Burne-Jones, were the focus of Jekyll's artistic talents for many years. Specially designed embroideries, wood-inlay work, and stencil decorations can be seen in the commission at 43 Hyde Park Gate, London, for Leonie and Jacques Blumenthal (Photographs 46 and 47). Flower decoration was an interest integral to design and horticulture, as can be seen in Photographs 48–50; it was the subject of a book that appeared in 1907, entitled *Flower Decoration in the House*.

Many of Jekyll's studies of rural subjects appeared in her book *Old West Surrey* in 1904, but as many interesting ones did not. Direct correlations can be seen between what Jekyll recorded in her photo-notebooks and how she later used the ideas. Her interest in cottage gardens has been detailed in two of her books, *Home and Garden* and *Old West Surrey*. The cottage-garden element that intrigued her in 1886 (Photograph 58) reappears in her Potting Shed at Munstead Wood (Photograph 57) in the late 1890's. The vine-covered arch that was recorded in a local cottage garden in 1887 (Photograph 60) is interpreted in her September Garden (Photograph 17). Doorways, such as those in Photographs 55 and 62, must have provided her inspiration in the design of doorways at Munstead Wood (Photograph 12). Local building methods and details were noted (Photograph 56) and reinterpreted (Photograph 66). The simplicity of a five-barred gate along a village road (Photograph 59) was inspiration for her own garden gate (Photograph 80).

The design and building of her house at Munstead Wood was the culmination of much keen observation. When she approached Edwin Lutyens to build her a house at Munstead Wood, he had already completed several buildings for her on the property, including The Hut and the Gardener's Cottage in 1894. The Gardener's Cottage (Photograph 20) was illustrated in *Old West Surrey* alongside old cottages as a good example of "a new cottage." This tiny cottage features half-timbering found in numerous local examples. Two sides were tile hung, and the back was built into the boundary wall. The Hut (Photograph 8) recreates many features that Jekyll documented in her photo-notebooks, such as the old cottages in Fittleworth (Photograph 69).

Lutyens' early sketches for a house at Munstead Wood in 1892–93, known between Lutyens and Jekyll as "Plazzoh," show a large Spanish-style villa of Bargate stone with heavy brick trim.[11] Fortunately Lutyens did a lot of traveling through rural villages with Jekyll in her pony cart, having the local building methods pointed out to him along the way. The final result in 1897 was an immensely comfortable house sited in her garden and grove that reflected and reinterpreted vernacular building traditions in Surrey.

The gardens that Jekyll created at Munstead Wood are the subject of numerous photographs in her photo-notebooks and are worth a separate study elsewhere in this book.

A CONTEMPORARY VIEW OF GERTRUDE JEKYLL'S HERBACEOUS BORDER

Michael R. Van Valkenburgh

Carol Doyle Van Valkenburgh

Nearly one hundred years have passed since the Victorian fascination with flowers found expression in the extraordinary gardens of the English designer and plantswoman Gertrude Jekyll. Since that time, the flower as a design medium has been in abeyance for a variety of reasons, including aesthetic considerations related to twentieth-century Modernism, economic factors, and an ambivalence toward flowers on the part of the profession of landscape architecture. However, recent examinations of historical precedents in the field of garden design such as *Italian Gardens* by Georgina Masson and *Garden and Grove* by John Dixon Hunt[1] have brought into focus the diversity of planted forms in which flowers have been employed in the built landscape. Today, renewed interest in the use of flowers is beginning to be seen in the late twentieth century efforts of landscape designers who are seeking to extend, or find alternatives to, Modernism and who have been reminded of the ability of the flower to elicit strong feelings and powerful associations.

This study of the flower configuration[2] known as the herbaceous border is part of a series of inquiries being conducted on the design use of planted forms in the built landscape.[3] As part of that inquiry, the authors came across information that led them to Gertrude Jekyll's remarkable photo-notebooks, which contain more than 2,100 images and which Jekyll kept as a photo-diary. Although Gertrude Jekyll's life has

been well documented in several biographies, these studies only begin to probe her thinking as a designer. The photo-notebooks, more than any other available record, shed new light on Jekyll's work as a designer and offer a rich collection of her design speculations.

Originally used by Jekyll to aid in her design work, the photographs, with occasional margin notes, illuminate her experiments with combining and integrating flowers and herbaceous plants in the landscape. One of the most interesting aspects of these photographs is their documentation of Jekyll's work with using plants to sequence movement through the garden. In addition the photo-notebooks reveal the broad range of her landscape-related interests, from straightforward photographs of flower arrangements in Photographs 48, 49, and 50, to starkly beautiful photographs that highlight the dramatic qualities of flowering plants in the garden, as seen in the image of a cloud of baby's breath hovering above shiny, dark bergenia leaves in Photograph 39. Other photographs include her studies of garden gateways, vernacular architecture, rural landscapes and rural landscape management practices, household objects, her needlework and stencil art, and portraits of her gardeners, her nieces, and other visitors to Munstead Wood. Mystery, humor, and death are present in some of her nostalgic images. One picture shows her gardener dressed in a monk's robe and hood standing beneath a towering lily-like *Cardiocrinum* (Photograph 43), an indirect reference, perhaps, to the influence on Jekyll's gardens of Pre-Raphaelite painters like Dante Gabriel Rossetti. Another photograph shows a cat recorded as a blur—shaking its head madly in a border of catmint. In another photograph, not included in this book, a deceased cat is recorded and captioned, "My Dear Toosey—dead." There is a conscious attempt in Jekyll's photographic portraits to incorporate the subjects into the landscape. In Photograph 79, for example, the young girl, Dorothea Strachey, shares the stage with the flowering shrub, Rose McFarland. This photograph is captioned simply, "Dorothea Strachey–Rose McFarland." In Photograph 73, the copse cutter is centered in the photograph below the ground plane, surrounded by alder trees. The composition, depth of field, and the high camera angle contrive to make him appear inseparable from the landscape he is tending. Though not intended by Jekyll for our scrutiny, the photographs and their notes provide a visual diary of Jekyll's interests, her experiments with plants, and a record of some of her completed designs.

Jekyll's garden design work, which began in the late 1870's and continued until 1932, concentrated on the application of the flower in a variety of landscape settings, including the woodland garden and the water garden, but most notably in the herbaceous border. Jekyll did not invent the herbaceous border, but she perfected it as an integral part of the spatial structuring of a landscape. She arranged flowering plants in carefully graded colors, in a long and precisely bounded rectangle, usually following the course of a wall, hedge, or mass of shrubs. This enclosure was designed to modify the ground-level microclimate, protecting the plants from wind, yet low enough not to obstruct sunlight. The width of the herbaceous border was

much less than its length, allowing for maintenance of the plants from each side.

Flowers have figured in gardens throughout history in various configurations, including the herbaceous border, the cottage garden, and another commonly recurring planted form, the parterre. Composed of bands of plants—often clipped box or yew—laid out in geometric or scrolled designs that formed decorative patterns, parterres were usually rectangular, and divided into sections. Their size could be extensive. Normally, they were sufficiently low in height as to seem two-dimensional and were intended to be viewed from a balcony or other vantage point above ground level. Parterres were frequently used in combination with sculpture and held a prominent position in sixteenth- and seventeenth-century Italian Renaissance gardens. Georgina Masson, the garden historian, discovered by studying garden plans and paintings of Italian Renaissance gardens that herbaceous flowers, exotic flowers, and bulbs, including foxgloves, lilies, and gladiolus, were added to the open spaces created by the patterning of the parterre.[4]

Parterres were also used to display herbaceous plants in French Renaissance gardens of the seventeenth century, where they were referred to as *parterres de broderie*. This early incorporation of herbaceous flowers in parterres in the pleasure gardens of the French and Italian Renaissance placed the ephemeral herbaceous flower in a more prominent position in the landscape. Most importantly, it transformed the two-dimensional, static parterre, bringing it closer in both form and materials to the herbaceous border. Parterres are known to have existed in England from the sixteenth century on, and Gertrude Jekyll's interest in these configurations is well known. She made several trips to Italy and France and included a parterre in the garden she designed next to the house at her mother's home, Munstead House.

Flower gardens, particularly flower borders, became a focus of garden design in England in the seventeenth century and continued to be developed over the next two hundred years, culminating in the herbaceous borders by Gertrude Jekyll in the late nineteenth century. Garden historian Robert Holden's research shows that herbaceous borders as an identified, separate element of the landscape were established in England at least as early as the eighteenth century and probably earlier. Herbaceous borders were used as one component of the *ferme ornée,* an ornamental farm popular in England in the eighteenth century, which involved "ornamentation of hedgerows with a wide range of shrubs and climbers and the addition of herbaceous flower-beds and borders in front."[5]

During the eighteenth century another type of garden is first mentioned by contemporary garden historians. The small cottage garden, composed predominantly of flowering plants, existed in the 1600's and possibly earlier. It became a pervasive configuration in the 1700's in the towns and waysides near the naturalistic landscapes of William Kent and Capability Brown, as cottage gardeners continued to tend herbaceous flowers in their yards. This not only represented the continued use of flowers in small garden spaces but also began to have an influence on garden design. Cottage gardens became popular again in

England in the nineteenth century. Gertrude Jekyll photographed these landscapes extensively in the countryside of West Surrey and made frequent references to both the economic benefits inherent in the use of old-fashioned hardy herbaceous flowers and to their formal simplicity. Images of these nineteenth-century cottage gardens are included in her photo-notebooks (see Photographs 58 and 60).

In the 1860's the Victorians focused considerable attention on the gardening practice of carpet bedding, more commonly known as "bedding out," which consisted of isolated geometric patterns formed by a variety of non-hardy exotic plants and annuals, in combinations of primary colors, such as scarlet geranium, yellow calceolaria, and blue lobelia. These beds were often isolated or placed randomly in groups on expanses of lawn near the house.[6] This practice was disdained by Jekyll and her colleague William Robinson (1835–1935), who advocated the use of more integrated flower borders composed of graduated shades of hardy herbaceous plants. However, in 1899 in *Wood and Garden*, Jekyll acknowledged that if "bedding out" was well designed, the result could be like a parterre in the "formal garden".[7]

Between 1500 and the 1850's the expansion of pleasure gardening and the aesthetic appreciation of cultivated flowers in England resulted in an increase in the number of cultivated plants, from a few hundred to over five thousand.[8] This vast expansion of available plants provided the extensive palette needed in the complex flower configurations of Gertrude Jekyll and her contemporaries. Finally, the design use of herbaceous plants and the emergence of the herbaceous border as a focus of garden design in the late nineteenth century were also encouraged in England by the climate of ample moisture and mild seasons throughout the year—growing conditions that were optimal for the cultivation of herbaceous plants.

Gertrude Jekyll was trained as an artist, first studying painting at the School of Art at South Kensington, starting in 1861. Later she pursued fine metal work, stencil art, and needlecrafts (Photographs 45–47). *The Handbook of Embroidery*, published by the Royal School of Art Needlework in the 1880's, contains two of her designs.[9] Jekyll's lifelong interest in plants and the garden can be seen in the sharply observed, decorative floral motifs of these early works. But hampered by increasingly severe myopia and by the resulting pain caused by repetitive close work, Jekyll turned from embroidery and other handcrafts to landscape gardening, and to a lesser extent to photography, as the focus of her creativity.

Pattern making as a formal concern in Gertrude Jekyll's designs for herbaceous borders originated in part in the aesthetic theories of the nineteenth-century Arts and Crafts movement, as exemplified by the work of the leader of this movement, William Morris. Decorative handcrafts of all kinds achieved new status as a result of the Arts and Crafts emphasis on useful handmade items which featured repetitive patterns. The Arts and Crafts movement also realized that mass production would never be capable of duplicating the superior quality of the handmade item. Evidence of this influence is represented in Jekyll's designs of inlaid doors and quilted curtains, shown in Photographs 46 and 47. Further evidence of this

influence, with its emphasis on craft, can be understood if one looks at each stage of the execution of Jekyll's herbaceous border: the design on paper, the preparation of the soil, the cultivation of the plants, and the careful weaving of color, texture, and shape, culminating in the garden in bloom.

The Arts and Crafts movement coincided with the emergence of the Queen Anne style in architecture, which favored craftsmanship and an eclectic borrowing from the historical periods of the past. The influence of this style on Jekyll can be seen in her photographs of ornamentation from this period. The Queen Anne movement also focused on the interdependency between the design of houses and their gardens, and Gertrude Jekyll and William Robinson were important leaders in this investigation. Mark Girouard points out, in *Sweetness and Light: The "Queen Anne" Movement 1860–1900*,[10] that there were other influences on the advancement of the garden art of Jekyll's era, such as the popular children's books illustrated by Kate Greenaway in the 1870's. These fanciful drawings of small manicured gardens instilled the idea of old-fashioned flowers and hedged private spaces in the minds of several generations and influenced the revival of the formal garden.

The intricate detailing of color in Jekyll's herbaceous borders was influenced to an even greater extent by the Impressionist painters of the era, such as Hercules Brabazon (1821–1906), a friend with whom Jekyll occasionally shared painting sessions (see Photograph 76).[11] The Impressionists were devoted to interpreting the color theories of the French chemist Michel Chevreul, who wrote about how the perception of color can be altered by the manipulation of contrast and proximity in *The Principles of Harmony and Contrast of Colors and Their Application to the Arts*.[12] His work provided the theoretical basis for the Impressionists and became the foundation for Jekyll's experiments and writings on the subject of color and flowers, culminating in her book *Colour in the Flower Garden* and in the execution of her Main Flower Border at Munstead Wood, which is discussed later in this chapter.

In the 1870's Jekyll began to turn away from needlework and painting to concentrate her efforts on the garden. In the mid-1880's she also began another pursuit, photography, which, whether by intent or by accident, was perfectly attuned to and served her work in the design of landscapes. Photography offered a way for Jekyll to continue her creative work despite her nearsightedness. She mastered all stages of the photographic process, including printing her own images, and she began to use her photographs as part of her work as a garden designer. The process of using a large-format camera and the resulting photographs offered Jekyll a way to see an image of the garden in its entirety through the photographs, something her nearsightedness prevented her from doing with the naked eye. By focusing the landscape onto ground glass she could produce images of work in progress to be examined, perhaps with the aid of a magnifying glass, in her study where she kept her photo-notebooks for frequent reference.

Certainly, one of Gertrude Jekyll's most important contributions to garden design was her sensitive

and unerring eye for the integration of planted forms such as the herbaceous border as elements of the larger garden. A comparison of two photographs from the photo-notebooks shows how Jekyll's design ideas were rooted in and traveled from the two-dimensional "painterly" realm of textile design to the far more complicated, three-dimensional world of the living garden. Jekyll was a collector of old patchwork quilts. At first glance patchwork quilts seem more analogous to "bedding out"—with its emphasis on two-dimensional geometry—than to the herbaceous border. But photographs of individual quilts from Jekyll's collection show one in Photograph 52 with an overall pattern that bears a distinct resemblance to the organization of an herbaceous border shown in Photograph 19, raising the intriguing question of whether a quilt may have served as an inspiration for the herbaceous border. Although the quilt in question was not designed or made by Jekyll, she was interested enough in the quilt to photograph it and keep the photograph in her photo-notebooks. The quilt is composed of long patterned stripes at each side with a broad neutral band at the center. A similar strategy about massing and framing can be seen in Photograph 23, of the hardy aster border. The enframement technique used in the long ends of the patchwork quilt corresponds to the outer perimeter of the double flower border, which Jekyll usually framed with hedges or masses of unclipped shrubs. Compositionally, the shrub masses suspend the refined colors of the flower border in a dark, solid green. The path down the middle, which parallels and separates the two flower borders, corresponds to the broad neutral band at the center of the patchwork quilt. In the flower border the green of the path between the borders is joined with the green of the surrounding shrub masses to complete the enframement in green, thereby uniting the colorful flower border and holding it within its landscape context. In this particular quilt, the enframement exists on two sides rather than on all four, but many patchwork quilts, including some in Jekyll's collection, were framed on all four sides in a dark, solid material similar to the enframement technique in the herbaceous border.

Designers of built landscapes have always struggled to resolve the question of how a space is to be viewed versus how it is to be used as a three-dimensional construction. Some landscapes are designed to be seen from one preferred vantage point, whereas others are conceived of as a continuum, with the goal being the establishment of a particular set of experiences based on moving through that landscape. But most landscapes attempt to work in both realms—pictorial and spatial. The photo-notebooks document Jekyll's struggle to reconcile both concerns.

An example of the way Jekyll integrated the herbaceous border in the landscape is provided by the photograph of a laburnum arch framing a floral allée of September perennials at Munstead Wood (Photograph 17). This photograph also shows how Jekyll intended the herbaceous border to be approached, viewed, and experienced. The laburnum arch anchors this garden in its landscape context, signals passage from one space to another, and invites the visitor to walk along the path between the borders. At the end of

the path, opposite the laburnum arch, is a five-and-one-half-foot-tall hornbeam hedge. A niche has been cut into the hedge to form a space for a bench at the end of the floral allée. The bench welcomes the visitor, provides the best static vantage point for looking back at the borders, and directs the visitor's attention back to the larger landscape beyond the arch (Photographs 18, 19).

Jekyll's photographs of flower borders rarely included elevations and were often taken from an end vantage point, emphasizing the border's linear quality. Even a wide and fully packed flower border appears thin and transparent if viewed across its width, but seen from one end, a border appears dense and full owing to the layering and overlapping of plants caused by the foreshortening of perspective. Viewing the flower border from either of its long ends also offers the advantage of obscuring gaps in the plantings caused by insect or weather damage. But most importantly, the overlapping condenses the volume of plants and makes their scintillating colors seem even more saturated. This was critical to the viewing of Jekyll's impressionistic compositions (Photographs 13, 16). Much has been said about whether Jekyll ever met the Impressionist painter Claude Monet (1840–1926) or visited his garden at Giverny. Whether or not they met, Monet's garden and Munstead Wood shared a number of details, including the use of allées of tall billowing flowers, which allowed one to stroll along and within a surrounding envelope of color. At Giverny this experience is made even more powerful and sensual, because the paths are less than three feet wide and in late summer many of the flowers are five feet tall.

The photo-notebooks reveal additional experiments in the integration of plants to sequence movement through a landscape. One series (Photographs 36, 37, and 38) examines the placement of clumps of herbaceous plants, known to Jekyll as "incidents." These incidents were placed in such a way as to offer directional cues in pathfinding and in the alignment of walkways and stairs. The first image in this series shows the stone steps near the house at Munstead Wood. On the top of the right wall of the steps is a small tub of light-colored maiden's wreath positioned in front of a dense, dark Scotch briar. In the distance and to the right is the drift of light-colored lilies, backed by a clump of European white birch. These are positioned at the edge of the woodland, near the entrance to the Green Wood Path. As Jekyll walked from the house to the staircase, the maiden's wreath clearly marked the top of the staircase and the change of grade. As she ascended the steps, her eye was first drawn to the maiden's wreath and then through the maiden's wreath to the lilies and birch in the distance. As she reached the top of the steps, the lilies and birch were in full view, and they signaled entry to the woodland path. On her way back from the woods, the maiden's wreath at the top of the steps was even more important and less subtle, because from this approach it signaled an abrupt change in grade at the staircase. Jekyll planned for the trunks of white birch trees to continue to serve as a cue after the lilies passed their bloom period. In the case of the maiden's wreath, the earlier, profuse blooms of the Scotch briar located behind it served as a cue in April and May. It is also

possible that Jekyll placed a new tub of flowering plants at the top of the steps after the maiden's wreath passed its bloom period. Whether Jekyll employed these "incidents" to deal with her nearsightedness as she walked about in the landscape, or whether she saw them as subtle artistic cues, working on the level of the unconscious for a normally sighted person, is unclear. Either way, they are brilliant examples of her design sensibility in sequencing the landscape, a realm quite different from that of the herbaceous border.

There are numerous other examples of cues to pathfinding at Munstead Wood, such as the seven-foot-tall mullein plants, which Jekyll often positioned at the corners of borders where a secondary path diverged from the main path. These were also used at an earlier date at the top of the previously mentioned stone steps. Another of Jekyll's techniques to signal the end of a border or the beginning of a diverging path was to plant one side of the corner of the border along the path with light or brightly colored, dramatically textured plants such as iris or yucca (see Photograph 12). The opposite corner of the border that frames the path was planted in low, fine-textured, or subtly colored plants. Sometimes, as in Photograph 9, the two corners of the border end at a hedge. In this instance the two corners of the border not only provide graphic visual contrast with each other, they also contrast with the hedge, and usually join with it, to signal passage from one space to another.

Jekyll's work with the herbaceous border drew upon her previous experience as a craftswoman and painter. She set about making sophisticated landscape translations of Michel Chevreul's color theories and those of the Impressionists when her own efforts in needlework and painting had to be discontinued because of her myopia. Jekyll took the Impressionist painting technique, which used thousands of tiny strokes of color to form a picture, and translated this into flower borders, where the petals or the flowers themselves were the equivalent of the Impressionists' brushstrokes. But instead of using the flowers to form larger pictures, Jekyll focused on combining flowers with the intention of exploiting the intensity of each use of color.

Jekyll's many books are currently available, and they document a number of her projects, including the development of single-color flower borders. (See the annotated bibliography at the end of this book.) Her work with color in the garden is evident throughout her writings and is summarized in her book *Colour in the Flower Garden* (1908). Fundamental to all of her work with color was her realization that each color is affected by its proximity to other colors—including those colors in the surrounding landscape as well as those immediately adjacent. Jekyll also followed a number of guidelines in her use of color in the design of planting details in a garden. She believed that by grouping tints and shades of complementary colors, such as red and orange, each of the colors in the group became more brilliant. She also found that white flowers or gray foliage plants added brilliance to color, because of their neutrality. In *Colour in the Flower Garden*,

Jekyll describes her experience as she walks through the orange flower borders and stops to look into the Grey Garden, which contained blue flowers and gray foliage plants:

> This filling with the strong, rich colouring has the natural effect of making the eye eagerly desirous for the complementary colour, so that, standing by the inner Yew arch and suddenly turning to look into the Grey garden, the effect is surprisingly—quite astonishingly—luminous and refreshing. [p. 101.]

Jekyll also emphasized in her writings the importance of color in ordering the observer's movement through a floral allée:

> Looked at from a little way forward . . . the whole border can be seen as one picture, the cool colouring at the ends enhancing the brilliant warmth of the middle. Then, passing along the wide path next to the border, the value of the color arrangements is still more strongly felt. [pp. 54–5.]

In this border, the juxtaposition of color and every detail of the view is calculated both to be enjoyed from one stationary vantage point and to be experienced as part of sequential movement through the landscape.

Jekyll's most scientific and experimental project was her famous Main Flower Border at Munstead Wood, where she attempted to represent the full range of the color spectrum. In *Colour in the Flower Garden*, she provided a description of this 200-foot-long, 14-foot-wide herbaceous border. In order to represent the entire spectrum, colors were distributed linearly, in gradations of chromatic separation, beginning at each end with violet, moving through cool colors, and ending with warm colors at the center:

> At the two ends there is a groundwork of grey and glaucous foliage. . . . With this, at the near or western end, there are flowers of pure blue, grey-blue, white, palest yellow and palest pink; each color partly in distinct masses and partly intergrouped. The colouring then passes through stronger yellows to orange and red. By the time the middle space of the border is reached the colour is strong and gorgeous. . . . [p. 51.]

Jekyll's translation of the color spectrum into a flower border required the use of a large variety of plants, all of which had to bloom in close sequence. But the coordinating of colors and timing of bloom was only half the work. Her knowledge of horticulture and her design skills, perhaps sharpened by her experiments in

flower arrangement, enabled her to successfully unite disparate forms and textures of flowering plants in the border. Her photographs offer a variety of solutions. One shows a continuous band of similar plants with gray foliage, which works as a unifying front edge, while the internal texture of the border remains diverse (Photograph 10). Another records the uses of contrasting color and texture to establish harmony with a few specimens of the graphic red hot poker and yucca, dotted among masses of finer textured flowering plants. Alternatively, she blended flowers of similar size and shape to establish harmony, as seen in Photograph 23, a long border of autumn asters edged with a variety of shorter North American woodland asters.

Despite Jekyll's rise in the 1980's to near cult status as a horticulturist, inadequate attention has been focused on her work as a garden designer. This has been due in part to the widespread belief among architectural historians that Edwin Lutyens, Jekyll's friend and colleague, was the designer of their collaborative gardens, with Jekyll providing only the plant selections. But a close examination of the photo-notebooks and the Jekyll garden plans included with the notebooks clearly contradicts this belief and clarifies Jekyll's substantial role as a designer.

One of the reasons so little is known about Jekyll's role as a designer is that her "laboratory," Munstead Wood, deteriorated shortly after her death and was later subdivided, making any on site investigations by design scholars next to impossible. The majority of Jekyll's design experiments were conducted in the privacy of her extensive gardens at Munstead Wood, West Surrey, in the English countryside, where she lived from 1896 until her death in 1932. Jekyll began the design of the landscape at Munstead Wood in the 1880's—almost a decade prior to commissioning the young Edwin Lutyens to design the buildings. Lutyens was only modestly involved in the design of this landscape. In the years that followed the initial collaborative work between Jekyll and Lutyens at Munstead Wood, Jekyll went on to design over two hundred gardens, many of these on her own and others in collaboration with Lutyens, who eventually became one of the most influential architects of the early twentieth century, and was also considered an accomplished landscape designer.[13]

The Jekyll and Lutyens garden plans for Folly Farm and Barton St. Mary, in the Documents Collection at the University of California, Berkeley, reveal some of the methodology of the Jekyll-Lutyens collaborations. Vellum overlays were passed back and forth through the mails, with Lutyens and Jekyll suggesting revisions to each other's work. These records clearly indicate that Lutyens and Jekyll merit recognition as design collaborators for Folly Farm and Barton St. Mary, though a complete study of plans of other gardens in the Berkeley archive has not been undertaken by the authors. An example of Jekyll's role as designer is provided by the original plans and the subsequent redesign of Folly Farm, Sulhamstead, Berks, attributed to Lutyens. A site analysis in Jekyll's hand records and interprets existing buildings, field lines, topography, and vegetation. Plans for the design of Barton St. Mary, East Grinstead, also attributed to

Lutyens, show Jekyll's refinements of Lutyens' preliminary site design drawings. Questions scripted in Jekyll's hand on a Lutyens drawing appear to have been made during a site visit and further explore her ideas for the resolution of a walkway that Lutyens had not acknowledged must traverse a steep grade. Jekyll proposed the addition of steps as part of the design of a path: "Wants stepping somewhere—here or further? Development?" later followed by "I think further," initialed by Lutyens. These exchanges demonstrate that Jekyll contributed to the physical structure of their collaborative gardens, particularly in terms of a carefully wrought response to site, a response often cited as one of the brilliant qualities of Lutyens' work.

Little has been written about Jekyll's work with seasonal display in the flower border. Each of the four main seasons is represented in the natural landscape by a succession of changes in the visual character of plants—some dramatic, some more subtle. Within each season are many microseasons or moments in which various plants come into bloom. Some of these moments overlap and their flowers form a nearly imperceptible collage of subtleties. In other moments the plants are so spectacular, colorful, and profuse that the gardener will choose to build an entire border or garden devoted to this moment. In *Colour in the Flower Garden*, Jekyll cautioned against attempts to represent all of the seasons in one flower border. Instead, Jekyll celebrated the microseasons in the garden by creating moments of harmonious crescendo— highlighting special recurring landscape events. To this end, Munstead Wood was organized around a number of garden spaces and areas in the woodlands, each containing herbaceous borders or other flower configurations, which were planned to bloom for a period of time as short as four to six weeks. The extent to which one of these areas could be devoted to a condensed period of bloom is illustrated by the Spring Garden—composed predominantly of a variety of flowering bulbs and drifts of low perennials that flowered in April, as shown in Photographs 3 and 4. Another example appears in *Wood and Garden*, where Jekyll described how she carefully positioned primroses in the woodland so their flower petals were tinted by the strong rays of spring sunlight passing through the opening leaves of overhead branches. Jekyll's need to create places of temporary perfection was expressed in these fleeting moments of beauty in the garden— hers was, in many ways, a romantic view of the landscape:

> What is one to say about June—the time of perfect young summer, the fulfillment of the promise of the earlier months, and with as yet no sign to remind one that its fresh young beauty will fade? [p. 77.]

In the design of her long herbaceous borders, Jekyll planned for the replacement of plants damaged by insects or violent storms. At times she also worked to obscure the visual record of the plant's life cycle once its "fresh young beauty" had faded. She kept tubs of "fillers" such as snapdragons or white hydrangeas

waiting in back-up gardens, or alternatively she pulled vines down from the back of the border and covered the flowering plants once they had ceased to bloom. In the woodland garden, tall ferns were interplanted with lilies to camouflage their yellowed foliage after the bloom period was completed.

For Jekyll, the desire to represent the seasons in the garden as a series of sublime, perfect moments was an aesthetic choice, but a choice that relied on her stern editing of those qualities of the landscape that were not definable by her as beautiful in a traditional sense. This choice represented more than an admiration for the craft of growing specimen plants or a response based on ecological considerations. It represented a romantic view of the world that Jekyll envisioned in the security of personal wealth and the privacy of a secluded, rural compound—a view that became increasingly less meaningful to other landscape designers who had begun to turn their design skills from the private garden to the new arena of public landscapes.

Unfortunately, the inevitable deterioration, and in some cases alterations, of Jekyll's gardens has undermined the ability of landscape designers and historians to learn at first hand about the finite expression of season and other design nuances of a Jekyll garden. The last recorded date in Jekyll's photo-notebooks is August 14, 1914, marking the beginning of England's involvement in World War I and the end of Jekyll's photographic record-keeping. Although she resumed some photography in the 1920's, those images are not part of the six photo-notebooks at the University of California at Berkeley.

Declining wealth in Britain in the 1920's, the global depression that followed in the 1930's, and the loss of the gardener who had cared for the high maintenance flower gardens contributed to the decline of many of the country estates designed by Gertrude Jekyll. These factors, combined with the rise of Modernism and the shift of emphasis from private gardens to civic landscapes, brought to a close the era of country estates in England characterized by Gertrude Jekyll's herbaceous border.

In the first decades of the twentieth century, while Jekyll was active as a garden designer and as a writer, the design use of flowers went through several revisions in the hands of other landscape designers. Some worked to extend Jekyll's practices, while others were pursuing new interpretations of flowers in the garden, more appropriate for the emerging public landscapes in the cities and towns of Europe and North America.

In the early 1900's, the American plantsman Lawrence Johnston and the husband and wife team of Harold Nicolson and Vita Sackville-West designed large private gardens in England, based in part on Jekyll's practices. Hidcote Manor, Johnston's garden in Gloucestershire, begun in 1906, was divided into rooms and included single-color flower borders, skillfully connected with walkways and level changes—a landscape reminiscent of portions of Munstead Wood. The most successful of the herbaceous borders in this still existing garden is the double red border, which follows a Jekyll principle that encouraged the integration of the foliage of the framing plants with the interior plants of the border through color and

texture. This border uses in its interior a succession of orange and red herbaceous flowers combined with roses blooming from July to October. A particularly interesting blend of shrubs with red-green and dark green foliage frames the border.[14]

Sackville-West and Nicolson built Sissinghurst—their own remarkable garden in Kent—starting in 1930. Unlike most Jekyll gardens, the plan of Sissinghurst is less integrated by framing in soft masses of green shrubs. Instead, the geometric plan uses masonry walls and hedges to define a series of autonomous garden rooms made accessible and bound together by an orthogonal path system and a series of rectangular lawns. A strategically placed center allée, from which the rooms and pathways depart, is formed by double, eight-foot yew hedges, joining the two sides of the garden and separating an orchard from the flower gardens. The experience of walking through this dark green allée isolates the visitor—both visually and spatially—and by its contrast intensifies the impact of color and pattern as the visitor moves out of the allée into the sun-drenched garden rooms at either end. The influence of Jekyll's work can be felt at Sissinghurst in the luminous white flower garden with its gray foliage plants, and in the brilliance of the orange and red garden.[15] Its rectilinear path system also shows the influence of early landscape Modernists like the French designer André Vera, whose books and projects were widely published around 1920.

In the United States, the landscape architect Beatrix Farrand adapted some of Jekyll's theories regarding the distribution of color in herbaceous borders in her 1926 design for the Abby Aldrich Rockefeller Garden in Maine. Farrand gleaned some of her inspiration from conversations with Jekyll at Munstead Wood in the 1890's, and from Jekyll's writings.[16] The flower borders at the Rockefeller Garden are significant because they translate the larger English herbaceous palette of Gertrude Jekyll into a less extensive list of plants capable of surviving the harsh climate near the seacoast in northern Maine, without losing the successful color gradations characteristic of the Jekyll gardens. Farrand revised the design of this garden over a fifteen-year period (not unlike Jekyll's annual revisions to Munstead Wood), initially creating a design that used an extensive rectangular bed of annual flowers at the center of the garden, flanked by herbaceous borders, and separated by pathways at the perimeter. In an early scheme, the middle of the annual flower bed was planted with blue flowers and graded away chromatically to other colors—an interesting and possibly not successful inversion of Jekyll's color spectrum in her Main Flower Border at Munstead Wood. Later, in the 1940's, Farrand simplified the design, replacing the entire annual flower bed with a flat panel of grass.[17]

Like Jekyll, Fletcher Steele (1885–1971), the Boston landscape architect, used herbaceous plants in borders, but Steele's work reflected greater simplicity than was typical of Jekyll's gardens, for example the iris borders at the Angelica Gerry Gardens at Lake Delaware, Delhi, New York, where he featured large, gently curved beds of blue iris.[18]

It is clear from Jekyll's work that the garden was much more than a plantswoman's preoccupation with flowers and a collection of formal exercises in design. For Jekyll and her successors, like Lawrence Johnston and Vita Sackville-West, the garden became an intangible focus of their lives—a living artifact which they nurtured and which gave back to them personal joy and spiritual solace. In her introduction to *Wood and Garden*, Jekyll describes the spirituality that she associated with garden design. Starting with a discussion of the craft of gardening, she writes:

> Let no one be discouraged by how much there is to learn. Looking back upon nearly thirty years of gardening . . . each new step becomes a little surer, and each new grasp a little firmer, till, little by little, comes the power of intelligent combination, the nearest thing we can know to the mighty force of creation. [pp. 5–6.]

The spiritual rewards the garden offered to Jekyll and her contemporaries were experienced as much in the craft of making and caring for a garden as they were in the visual spectacle of the garden at the peak of its beauty.

The garden of another designer working concurrently with Jekyll at the turn of this century provided an interesting contrast to her work and set the stage for the next major theoretical movement in the arts, Modernism. The French landscape architect Jean Forestier (1861–1930) appears to have attempted to use flowers in the garden to establish a subtle narrative about the cycle of the seasons. He chose to do this not in a private garden, accessible to only a few, but in a public setting frequented by scores of people in a single day. Forestier's 1906 design for an iris garden was added to an existing open space, the Parc de Bagatelle in the Bois de Boulogne, Paris, and features the entire annual cycle of one genus of plant as the focus of the design. The garden consists of a single room hedged by twelve-foot yews. A narrow rectangular water rill at the center of the room is filled with a water-tolerant iris species and is flanked by similarly rectangular, iris-filled borders.[19] The irises command the entire space, in part because of the strong impact made by the massing of one flower genus, and in part because the graphic qualities of the flowers and their foliage provide a counterpoint to the stolid and unchanging hedges of dark yew. Though the bloom period of the mixed iris species is less than ten weeks, the quality of the space during the remainder of the year is conditioned by seasonal changes in the iris foliage.

Forestier's positioning of the iris garden near a major entry to the park notes the intention that the public accept the annual cycle of plant growth and decline. The gradation of leaf and flower color from spring through winter embraces seasonality in a symbolic gesture, using plants to mark time. By following the entire growth cycle of a plant, Forestier's design departs from Jekyll's conventions. For Jekyll, the

decline of foliage was accepted as a necessity, a variation of the character of herbaceous plants and an inevitable condition. In contrast, because of the exclusion of all other herbaceous plants, Forestier's garden with its profusion of iris flowers in spring and early summer celebrates the pinnacle of a cycle that, for completion, relies not on other flowers blooming in other seasons, but on the evolving qualities of the iris foliage throughout the year. On warm days in winter, when the shriveled and brown iris leaves are barely discernible, Parisians from all walks of life can be seen strolling in the garden, incorporating memories of the iris with whatever may have prompted their need for a moment of solitude.

The eventual rise of Modernism as the dominant movement in art and design in the twentieth century was an important factor in the decline of the flower as a focus of landscape design. Modernists were uncomfortable with the symbolic or referential aspects of the built environment, which conflicted with their belief that they were molding permanent and unchanging spaces that were not specific to a particular culture and its history. Modernism grew to prominence in the 1930's and dominated the field of landscape design in Europe and the United States until the 1970's. The effort in the United States to assert landscape architecture as a profession started early in the twentieth century, and later aligned itself with the concerns of the profession of architecture in its preference for the austerity of Modernism. Landscape architecture defined itself broadly to include the design of gardens and parks as well as large-scale land planning. The image it was trying to convey was inconsistent with the elaborate, Victorian-influenced flower gardens and the associations prompted by the presence of flowers in the domestic rituals connected with birth, marriage, and death.

Avoiding flowers and their sentimental associations suited the canons of Modernism, which emphasized bold, abstract spatial composition and de-emphasized the crafting of finite details. The Modernist aesthetic, exemplified by the Bauhaus, emulated the sleek, functional machine. Flowers were the antithesis of Modernism. They weren't easily molded, they were never permanent, they were hardly ever sleek and were only occasionally functional.

However, flowers remained visible in gardens in Europe in the 1920's, in the work of those early Modernists who were able to transform the versatile flower and integrate it in new ways. These designers tried to apply the Modernist interest in three-dimensional compositions—which featured walls, planes, and level changes—to the landscape. Their work was part of the International Exhibition of Decorative Arts in Paris in 1925, for which Jean Forestier was the inspector general. An example of this type of garden can be seen in André and Paul Vera's 1920 design for a cubistic garden at Saint-Germain-en-Laye, in Yvelines, France, which used flowers and hedges in a parterre-like rectangular configuration. The internal patterning of this garden arranged plants in a series of acute triangles in contrasting colors. But despite the efforts of the early Modernists to incorporate the flower in their gardens, the mainstream of the profession eventually

relegated it to an ancillary role, in favor of almost entirely flowerless compositions modeled after the abstract works of Cubism and Constructivism, such as the sculpture garden of the Museum of Modern Art in New York City, designed by the American architect Philip Johnson in 1953, or the Miller Garden in Columbus, Indiana, designed by the American landscape architect Dan Kiley in 1955.[20]

An overview of Gertrude Jekyll's work in the context of the emergence of Modernism is provided by landscape architect Christopher Tunnard (1910–1979) in his 1938 classic, *Gardens in the Modern Landscape*. Tunnard's view of Jekyll's work is representative of the attitude of the profession of landscape architecture in the years to follow. He is critical of Jekyll's gardens, especially of her experiments with color, noting they were too intellectual. In some respects this criticism seems wrong-minded, particularly with regard to her single-color borders that were well integrated spatially. His criticism has more validity with respect to the long border with its graded colors of the entire spectrum, which no doubt was more appealing if you were nearsighted and experienced it as a succession of color transitions rather than as a whole. Still, from the vantage point of 1988, and given the paucity of design exploration yielded since 1938 by landscape architects, Jekyll's spectrum border was clearly an important experiment.

Tunnard also points out that by the 1930's the flower garden had become a cliché, particularly in England, where practitioners were unable to get beyond it, despite the influence of their colleagues in architecture who were practicing the emerging Modernist style.[21] The flower border as one element of an integrated landscape had been taken over by hobbyists. Ironically, Jekyll's thoughtful and informative books encouraged these people—many of whom idolized her, but lacked her training, her skills, her design sense, and her vision. There was a fear on the part of landscape designers of being associated with the then unpopular Victorian era and the aura of amateurism symbolized by the flower garden.[22]

In *Gardens in the Modern Landscape* Tunnard also recalls the social conscience of the Modernists. They wanted to provide new housing and appropriate low maintenance landscapes for the economically disadvantaged. The association of the Jekyll flower gardens with the privileged upper classes conveyed a sense of elitism that was contrary to the social concerns of many of the early Modernists. But despite these feelings on the part of the Modernists, the flower remained common in vernacular gardens and landscapes throughout the twentieth century—as it has throughout history—although it remained suspect for most landscape architects in the United States and for many in Europe as well.

As we approach the end of the twentieth century, designers are taking a second look at incorporating flower configurations as an integral element in both public and private gardens. In the next decade we may see designers using the flower in overtly symbolic ways, perhaps building on efforts like the provocative use of flowers represented by the Mémorial de la Déportation, on the Isle de la Cité, in Paris, designed by Henri Pingusson in 1961. The memorial is located underground, but it features a public landscape consisting of a

simple open space at ground level. The space is marked by a ceremonial row of individual beds of everblooming roses parallel to an adjacent row of large tree stumps along the sidewalk. This landscape is notable for a number of reasons. The economical use of one species of everblooming rose is a low-maintenance but highly visible choice, and the juxtaposition of the beds of roses with the tree stumps that were most likely existing or were left when the trees had to be cut down to accommodate the underground memorial is an imaginative response to conditions on site. The landscape at the Mémorial de la Déportation is interesting in other ways because it borrows from a number of flower configurations to create something new. Like the herbaceous border, the garden emphasizes heavily blooming plants. Like the parterre, it uses flowers isolated in space in raised beds surrounded by low grass without any enframing hedges. The raised bed was a common technique in the kitchen garden, a variation of the cottage garden. But despite the combining of elements from historical configurations, the design of this garden is contemporary. The flower beds are laid out in a grid that parallels the tree stumps at the edge of the sidewalk. The dramatic and highly visible placement of the rows of everblooming roses and the remains of the severed trees at the street side of the space combine to establish a symbolic and emotional threshold for this memorial to the victims of one of history's most brutal crimes.

Landscape architecture is expanding into new realms to respond to the imperatives of a world that is more complex and more tentative than Jekyll's world and the decades when Modernism emerged. The design aesthetic of landscape architecture is currently adjusting and extracting lessons from its own recent history, including, one hopes, from both the substantial contributions of Gertrude Jekyll and the achievements of Modernism. What is needed now is neither a revival of the Jekyll flower garden nor a continuation of Modernism per se, but a continued search to make expressive and meaningful landscapes that either fit or challenge the diverse needs of a rapidly changing populace around the globe.

If the current interest in flowers is to yield a more enduring place for flower configurations in the landscapes of the future, designers must continue to struggle to reconcile the sometimes conflicting issues of the art and craft of this complex, maintenance-intensive, living medium. The art of designing flower gardens cannot be separated from the knowledge of the craft of building them, nor can designers make the assumption that the implementers of their designs will take care of the details. Designers in the years to come will need to combine their vision of a new landscape architecture with an understanding of historic planted forms, including their formal structure, the cultural circumstances that fostered their invention, and the rich associations they have been able to convey since the beginning of civilization. If the profession of landscape architecture is to reach its full potential, the context for the use of flowers and other planted forms must involve new and unfamiliar garden types, in public and private settings.

One wonders what Gertrude Jekyll thought about as she walked through the Spring Garden a few

weeks after the last tulip petals had fallen and the leaves had begun to yellow and ripen. Sometimes a garden's greatest solace lies in the place it holds in our memory. At other times, the value of a garden resides not in our thoughts about the garden, but in the darker, more mysterious thoughts that it permits amid the reassurance offered by its presence in our lives. The garden one returns to, year after year, builds memories, not only of itself, but of the thoughts and events one brings to and takes from the garden.

The public has always known that flowers have much to offer. The reassuring sight of cultivated flower beds, the fragrance of rows of nearly spent peonies bending their heads to the ground after a storm, the luminous color of clear orange daylilies in mid-summer, or the stark amber foliage of dried daffodils, flattened to the ground after a November frost—all of these fleeting images of flowers underscore our own mortality and place us within the stream of time. Landscape architects of today and tomorrow should be able to draw freely but wisely from all of the possible design uses of flowers, to bring a resonance to landscapes of the future that incorporate the lessons of the past. Designers will continue to be indebted to Gertrude Jekyll for recording her speculations about the design uses of flowers and her knowledge of the craft, and for reminding other generations of the fecundity of this powerful living medium.

THE SEASONS OF

MUNSTEAD WOOD

1888–1914

Judith B. Tankard

For nearly forty years Munstead Wood was the home of Gertrude Jekyll. It was the result of much consideration and careful planning, from the early stages of defining the boundaries and laying out the gardens to the building of the ideal house ten years later. During the middle years, as the gardens matured and new gardens were set out to augment or replace earlier ideas, Munstead Wood became a symbol of a fading era and the goal of a pilgrimage for the privileged few. The final years, reflecting Jekyll's restricted activity and quiet contemplation as well as changing social conditions, saw the unavoidable decline of the gardens. Today, almost sixty years after Jekyll's death, Munstead Wood still lingers in the mind as a once-perfect integration of home and garden. It remains the object of much curiosity, and attracts modern-day pilgrims in search of the elusive. Munstead Wood as it was in Gertrude Jekyll's time no longer exists, however, as the character of the property has been altered to accommodate the realities of the present age and almost all of the plantings have disappeared. Fortunately invaluable material such as Jekyll's own writings and hundreds of photographs, as well as recollections of her friends, presents us with an extraordinary record of Munstead Wood, probably the most thorough visual documentation of any twentieth-century landscape.[1]

Because Jekyll was a prolific writer and chose to describe and illustrate the various parts of her gardens at Munstead Wood from the early 1880's until 1932,[2] present-day admirers can appreciate the scope of the gardens, but may experience difficulty in understanding how they all went together. The sequence of photographs in this book entitled "The Seasons of Munstead Wood" was selected to present a vision of

Jekyll's gardens over the several decades that she photographed them. The captions try to define and locate these gardens.

The attempt to pinpoint the exact location of specific images taken in the gardens has been based on Jekyll's own descriptions and plans, especially those in *Colour in the Flower Garden* (1908) and *Gardens for Small Country Houses* (1912), as well as plans that survive from the architect, Sir Edwin Lutyens, and the surveyors, Peak, Lunn, and Peak.[3] Although there is a great volume of material in the available descriptions and plans, there is much information that is missing or misleading. The garden and woodland areas that surrounded the house are well documented in plans, but there are no surviving plans by Jekyll that locate the gardens in the working areas of the property, including the so-called Grey Borders that were copiously photographed for magazine articles that Jekyll published near the end of her career. Some of Jekyll's descriptions are somewhat puzzling without the benefit of a plan, some of the plans are inconsistent with the descriptions, and the architectural elements in Jekyll's plan of her garden published in 1912 differ slightly from those of Lutyens' layout of 1893. Without access to the diaries that Jekyll kept every day of her life,[4] it is impossible to know precisely the timetable that Jekyll used in the design and implementation of her garden.

The plan of Munstead Wood that accompanies the photographs will give the reader some sense of the scope of the gardens as they were during the years that Jekyll photographed them (c. 1888 to 1914). Following Jekyll's own system of noting the photograph number and the photographer's viewpoint with an arrow on her published plans and accompanying photographs, it was decided to attempt the same whenever possible. The plan itself is a composite based on Jekyll's overall garden plan of 1912, Jekyll's plans of 1908 for specific gardens, the surveyors' plan of 1883, and Lutyens' overall plan of 1893 as well as his partial plans of 1896. An Ordnance Survey map of 1916[5] was used to pinpoint the exact location of several of the other buildings on the property, such as The Hut, the Quadrangle, the Thunder House, and the Gardener's Cottage. It was used in conjunction with a current 1:2500 Ordnance Survey map for comparison.[6] The resulting plan is by no means entirely accurate, but it does provide a starting point from which to begin to understand the complexity of the plan that formed the framework for Jekyll's creative use of plants.

The use of Jekyll's names for plants, as referred to in her garden plans and writings, has been retained in the description of her gardens that follows, even though these names may represent outdated botanical nomenclature or may refer to plants that are no longer obtainable. For the horticulturist, a useful glossary of plant names by British plantsman Graham Stuart Thomas is included in one of the recent reprint series of Jekyll's books, and *Gertrude Jekyll on Gardening* (Boston: David R. Godine, 1984) by Penelope Hobhouse refers to current botanical names.

THE HOUSE

In October 1897 Gertrude Jekyll moved into her house at Munstead Wood, after years of living with her mother across the road at Munstead House and later living at The Hut while her own house was being built. She writes:

> My own little new-built house is so restful, so satisfying, so kindly sympathetic. . . . In some ways it is not exactly a new house, although no building ever before stood upon its site. But I had been thinking about it for so many years, and the main block of it and the whole sentiment of it were so familiar to my mind's eye, that when it came to be a reality I felt as if I had already been living in it a good long time.[7]

It was designed by Edwin Lutyens, after one false start, and "the building of the house was done in the happiest way possible, a perfect understanding existing between the architect, the builder, and the proprietor."[8] In *Home and Garden*, Jekyll describes the amiable relationship with Lutyens, reporting that the "fur flew" on one occasion when she cautioned him that "my house is to be built for me to live in and to love; it is not to be built as an exposition of architectonic inutility!"[9]

Jekyll's new house was carefully sited in a chestnut copse to complement her already existing woodland garden (Photograph 1). Jekyll had been working on the woodland plantings and some of the more formal garden elements since the late 1880's, after buying the 15-acre property in 1883. Over the years she had established rhododendron plantings[10] (Photograph 2) at the edge of the lawn, set among birch, chestnut, or oak seedlings that she creatively selected after the property had been deforested in prior years. The rhododendrons were carefully grouped according to color, with pink, white, rose, and red in the sun and purple reserved for the shade. In a clearing in the woods there was an azalea garden quite separate from the rhododendrons. Through it ran a grassy path, one of several paths created throughout the woodland. "One of the first considerations was to provide pleasant and and easy means of getting about among the trees."[11] The paths consisted of two major grassy paths and three lesser paths through the woods, each with its own character. Jekyll considered her Wide Wood-Path (Frontispiece) her most "precious possession"; the plantings in the widest path were treated the most boldly. The house is sited so that from the windows of the sitting room (Photograph 1) she could look down the path, with one of the few Scotch firs that remained forming a vista point. *Cistus laurifolius* (rock rose) was one of the plants that Jekyll used to soften the transition from lawn to wood, in her words, "to make the garden melt imperceptibly into the wood."[12]

THE SPRING GARDEN

As part of the greater scheme for the landscape at Munstead Wood, Jekyll developed some gardens for specific bloom periods. Early on in the development of the gardens, Jekyll wisely observed that because it is impossible to keep any border or garden area at optimum performance throughout the growing season, it is best to create a series of special gardens that offer maximum interest for a short period of time. The Spring Garden was one of these areas. Although the outlines for the garden appear on Lutyens' plan of 1893, illustrations of it only begin to appear in her book *Colour in the Flower Garden* in 1908.

"When planning a garden for spring flowers it is extremely desirable that it should be somewhere apart; in some place on the outskirts of the general garden, such as need not necessarily be visited in the summer months."[13] Jekyll's Spring Garden was designed in a sheltered place, so that one side was the back of the high sandstone wall that separated it from the Main Flower Border, two other sides had low walls, and the fourth consisted of a group of holly trees and yew hedging (Photograph 3).

The bloom time was designed from the end of March to mid-May, and the principal mass of color was displayed in the main border that ran alongside the high wall. The background foliage that she chose to highlight the color masses was *Veratrum nigrum* (false hellebore), *Myrrhis odorata* (sweet cicely) and *Euphorbia wulfenii*. The border consisted of carefully graded color masses, ranging from large drifts of pale colors at the foreground to deeper colors in the background. The colors were achieved with a mixture of bulbs and plants, such as primroses, tiarella, wallflowers, arabis, and iris (Photograph 4). Several adjacent narrow borders consisted of red primroses or tree peonies, with roses trained in arches overhead. The central area was grassy and focused on the splendid holly trees; the rock outcropping, known as "near rock" and "further rock," was embellished with cascades of blue and white flowers, set off with the reddish foliage of *Heuchera*. To extend the season further, garlands of *Clematis montana* were strung on ropes between cob-nut trees (Photograph 28) and over a doorway that led to other areas of the garden in the summer.

Another area that was set aside for spring bloom was the Primrose Garden (Photograph 5), located in a beech-hedged grove under large oaks northeast of the house, although its precise site is no longer known. Here Jekyll had massive plantings of her special "Munstead Bunch" primrose, having found the original specimen in a cottage garden in Farncombe around 1873. She carefully selected the specimens with white and pale yellow tones over the years and established a separate area for

them, surrounded by oak and chestnut trees. The primroses were planted in the undergrowth among hazels.[14] This garden captured Jekyll's interest for the longest time; in the year that she died she was carried out to have one last look at the garden of primroses.

THE HIDDEN GARDEN

From the end of May until mid-June—"Between Spring and Summer"—there was a short-lived garden known as the Hidden Garden (Photograph 6), created possibly in the early 1900's. Only a handful of photographs document its short life, and its exact location remains perplexing. Jekyll's plan of the the June Garden in *Colour in the Flower Garden* places it on the southeast side of The Hut, while the carefully drawn plan for the Hidden Garden in the same publication looks similar to an area known as the Rock Garden in an area northwest of The Hut. It was hidden among shrubbery near the lawn with no clearly defined entrance. It consisted of a series of paths through the rocky areas that were embellished with early-June-blooming flowers. All were surrounded by young cypress, holly, ilex, and yew plantings. As the evergreens grew they crowded out the sunlight and the garden then became a fernery. The coloring in the garden was "quiet" and consisted mostly of *Phlox divaricata*, *Arenaria montana*, hellebores, Solomon's seal, London pride (*Saxifraga umbrosa*), and *Iberis sempervirens*. Nepeta, iris, columbine, and tree peonies highlighted the area, with clumps of lilies and ferns at the outer edges. Near one of the three entrances rose "The Garland" tumbled out onto the yew.

The lawn plantings of flowering shrubs were a major part of the early June interest, and one of Jekyll's favorite plants was *Exochorda grandiflora*. Plantings at shrubbery edges, especially early lilies and ferns (Photographs 36–38), were an important part of the scheme.

THE JUNE GARDEN

The June Garden at Munstead Wood surrounded the cottage known as The Hut that Lutyens built in 1894 for Jekyll to use for entertainment and crafts pursuits while living at Munstead House. A small building with only two bedrooms, it was designed as a recreation of a Surrey tile-hung cottage. When Jekyll's brother Herbert inherited Munstead House, Gertrude moved into The Hut to await the building of her own house. While living in The Hut, located only eighty yards from the

building site, she could keep an eye on the construction of the new house and tend the cottage garden that surrounded it. The Hut was hidden from the main house by yew, ilex, and laurel shrubbery, with the Hidden Garden nearby, and sheltered by one birch and two oak trees. One entrance to the cottage was by a paved path through an arched tunnel of yew (Photograph 7). The front and back of the cottage were planted out with a riot of June-blooming plants, predominantly lupin, iris, and peonies, all contained within low boxwood edging.

The intensively planted borders were further embellished with a cascading rose "The Garland" (Photograph 8), and the holly tree near the cottage had *Clematis montana* trained up it. Unfortunately there are only a few photographs of this garden, but Jekyll did provide a excellent plan and description in her book *Colour in the Flower Garden*. Each border had a different color interest, all featuring pale or cool colors. For example, in the border at the lower right of The Hut on the plan, the lilac and purple tones were achieved with lupin, nepeta, iris, and geranium; pink tones with London pride and peonies; and white accents with foxglove and meadowsweet (*Aruncus sylvester*). Further accents were the yellow tree peony and the Oriental poppies. An adjacent border consisting mostly of China roses had the odd addition of giant hogweed (*Heracleum mantegazzianum*) and mullein for interest.

Jekyll's writings after 1910 rarely refer to this June garden, leading one to suspect that it may have been short-lived due to a shift in interest to the planning of the summer gardens that surrounded the working areas of the garden. June plantings in other areas of Munstead Wood did abound, especially the climbing vines on the main house and the display of Scotch briar roses, rosemary, and China roses on the south side of the house (Photographs 35 and 36).

THE MAIN FLOWER BORDER

Jekyll's most spectacular color essay was her 200-foot-long hardy flower border, fourteen feet wide and ideally backed by an eleven-foot-high sandstone wall. The border was divided into unequal east and west ends, with a path at the back for the gardener's access (Photograph 11). Although designed for primary bloom time from July to September, the border was cleverly planned so that it looked attractive at other times of the year with "incidents" of bloom. Not all the plants used were hardy perennials; in early June bedding plants such as geranium, salvia, verbena, and begonias were used. The design of the Main Flower Border was the result of years of experimentation and careful observation at Munstead House where she had a 240-foot-long border,

. . .the brilliancy [of which] was beyond anything we had seen in the way of hardy flowers. . . . The great point in this border is the grouping of colours in broad masses. . . . It is this soft and insensible transition from one mass of colour to another which is so effective. . . . [She] is an artist who is well acquainted with the harmony of colours [and who] knows exactly when to keep each separate, and in what degree to mix them so as to produce the proper effect.[15]

The groundwork of foliage was gray at either end to deeper greens in the middle to complement the flower colors, which were carefully gradated from pale pinks, blues, yellows, and creams at the ends, to deeper tones of yellows, pinks, and blues, to an intense center of oranges and reds.[16] Plants were arranged in large masses of color so that they would be effective for viewing from the house. In order to keep the border going from July to early October, Jekyll had to cleverly camouflage dead or dying material by introducing tubs of plants or greenhouse plants, or, most creatively, encouraging the back or middle plants, such as gypsophila, to cascade over the deadheads (Photograph 13).

Comparison of Photograph 9, taken in the 1890's, with Photograph 10, taken in 1914, shows that the basic design concept for the plantings did not change. The break in the border to allow entrance to the doorway in the wall was edged with bergenia and stachys and accented with *Yucca filamentosa*. In Photograph 12 it can be seen that the yuccas have been cut back to keep their height in proper scale. The wall and doorway that separate the Main Flower Border from the Kitchen Garden and the Spring Garden were heavily planted on both sides with hardy vines, including *Clematis montana*, shown in June bloom in Photograph 14. The border was further defined with yew hedging at either end and a stone seat at the east end, adjacent to the end of the Pergola.

AN AUGUST GARDEN

The gardens at Munstead Wood that saw the most active experimentation were those that were in the working area of the property, adjacent to a picturesque group of buildings known as the Quadrangle. Up until about 1909, Lutyens created or renovated a series of farm buildings, including stables with living quarters, a barn, and a stone-stepped loft. Flanking these buildings Jekyll created a series of borders basically in gray or gray and pink colorations and described and illustrated them for at least twenty-five years after establishing the earlier gardens around the house. Unfortunately there is no general layout for this garden, variously referred to as the Kitchen Garden and the Grey Garden. Jekyll's description in *Colour in the Flower Garden* mentions a low stone wall, hedging, and

garlanded archways flanking the loft building, some elements of which can be recognized in most of the photographs. How all of the borders and the hedging related to one another remains a mystery.

An early image of the Kitchen Garden (Photograph 15) shows the housekeeper standing in a double-bordered pathway in front of the wood-clad loft building, at one time used for seed storage and potpourri-making. Just in front of the building are fine-textured lavender hedges that define the garden edges. These summer borders began to bloom in June and lasted until late September. They were at their height of interest in August. Jekyll writes:

> The dark foliage of the Fig-tree at the end, which covers an arched recess under a stone staircase leading to a loft, and the silvery-grey of the weather boarding of the buildings, make a pleasant and suitable background to the little garden.[17]

The groundwork for the borders was a symphony of gray foliage, including *Stachys lanata* (lamb's ears), santolina, *Artemisia ludoviciana*, *Cineraria maritima*, and nepeta (Photograph 16). She planted summer flowers in the pink and white range in at least one border, and other variations in the remaining borders. Numerous images of these gardens show, in addition to a hollyhock garden, one set aside for lupin, iris, and delphinium, and another for cascading June roses.

THE SEPTEMBER GARDEN

The culmination of the garden year must have come in September, judging by one of her most sublime images (Photograph 17). The laburnum arch served as an entry gate to the September Garden, which was located in an area backed on each side by a 5½-foot-high hornbeam hedge and framed by the vernacular-style Gardener's Cottage in the distance (Photograph 18). The double gray borders consisted of gray foliage in the front and September-blooming asters, called Michaelmas daisies, in the middle along with additional drifts of pale pink or yellow flowering plants (Photograph 19).

The Gardener's Cottage (Photograph 20), now known as Munstead Orchard, was designed by Lutyens in 1893, at the same time he designed The Hut and the earlier version of Munstead Wood. It was built in 1894 for Jekyll's Swiss gardener, Albert Zumbach, and is located at the far end of the property in a fruit orchard.[18] This tiny cottage was an exercise by Lutyens in the art of reinterpreting Surrey vernacular architecture. In addition to half-timbering motifs, no doubt picked up from some of the local examples that Jekyll photographed, such as Great Tangley Manor and Unstead Manor Farm, the cottage was also tile-hung. Since the cottage is at the narrow end of the triangular

Munstead property, Lutyens built one side of it directly into the sandstone wall that surrounds most of the property. This end was further defined by a sheltering hedge of Lawson cypress (*Chamaecyparis lawsoniana*) with three arched openings, which Jekyll installed in 1887 and which still remains.[19]

OCTOBER GARDENS

As the gardening year progressed, the plantings nearer to the house came into flower. In an area close to the main house Jekyll established her so-called "Autumn-blooming Shrubs" which she identifies as *AEsculus macrostachya* and *Olearia haastii* (daisy bush) (Photograph 21). Along an adjacent border, visible from the upstairs gallery of the house, she created a late-blooming Michaelmas daisy border. These October asters were of cool blue and lilac coloring, without the yellows of the September borders, and included *Pyrethrum uliginosum* (chrysanthemums) and edgings of *Elymus arenarius* (lyme grass) and *Stachys lanata*.

As in most personal gardens, the evolution of the design of the gardens at Munstead Wood and their execution is necessarily an incomplete story, as there are only pieces of information available. What is known, however, is that Munstead Wood was the result of a remarkable partnership between two highly talented individuals, Gertrude Jekyll and Edwin Lutyens.[20] When they met each other in May 1889 they embarked on a personal and professional relationship that produced a series of about fifty design projects that have rarely been surpassed for their sensitivity to composition and materials. Their collaboration was especially remarkable because it is difficult to tell precisely where the work of one ends and that of the other begins. Previously it was assumed that Lutyens provided the landscape and garden layouts and Jekyll filled in the spaces with the plants. It has become apparent that Jekyll played many roles in the collaboration. In addition to her horticultural knowledge and planting design genius, she had a design sense and attention to detail that played an immense role in the young architect's developing sense of style. Although the garden at Munstead Wood is important for a number of reasons, the most significant one is that it was in this first major design collaboration that Jekyll and Lutyens initiated many details that were incorporated into later jobs.

Only a small group of sketches and plans remain from what must have been a large amount of material engendered by many conversations between architect and client about the house and gardens at Munstead Wood. One of the earliest records that survive is Lutyens' "Munstead Wood Sketch-

book" of 1892–93, a tiny notebook of thirty pages filled with pen and watercolor sketches of the earlier proposed house at Munstead Wood, The Hut, and the Gardener's Cottage.[21] Although no plan for the present house survives, there are a few designs for specific details within the house.[22] Plans for the property and gardens range in date from the surveyors' plan of November 1883 to Lutyens' stable renovations of June 1909, but only one of Jekyll's many sketches for the gardens survives, the undated "Michaelmas Daisy Borders."[23] The two most interesting plans are the survey plan of 1883, locating all the major trees on the property, and the plan that Lutyens prepared in 1893 that details the amount of work accomplished by Jekyll that preceded Lutyens' involvement.

The 1893 plan for most of the property at Munstead Wood, as valuable as it is, does not differentiate between proposed and built elements. It shows the "false start" house, the three buildings known as the Quadrangle, and the Potting Shed, as well as the sandstone walls, the Lawson cypress hedge, the woodland walks, the Pergola, the Main Flower Border, and the Spring Garden. It does not show The Hut or the Gardener's Cottage, both of which had been built by 1894. Lutyens designed a number of other buildings on the property, including the Mushroom House, whereabouts unknown (Photograph 66), the Thunder House, and possibly the Potting Shed (Photograph 57). The Thunder House of 1895 is a curious stone building located "at the far end of the kitchen garden, where the north and west walls join at an uneven angle."[24] It was here that Jekyll could not only watch thunderstorms but also have an elevated view of the open countryside beyond her woodland.

One of the innumerable enigmas of the execution of the elements in the overall landscape design is that although the high sandstone wall behind the Main Flower Border was built before the border was planted, it was constructed only after the Pergola was built. A photograph published in 1893 of the obviously newly built and unplanted Pergola[25] shows the Potting Shed at the end of the vista, but no sandstone wall or flower border to the right. When the wall was eventually built, it not only backed the border but turned the corner to screen the shed from view on the main lawn. It is curious that the Pergola was built before constructing the walls. Some of the work that Jekyll undertook before meeting Lutyens in 1889 can be seen on the 1893 plan, including the Lawson cypress hedge of 1887 and the development of the paths in the woodland gardens in the 1880's. Jekyll notes:

> Much of the ground had to be laid out, in some kind of way, before it was known where the house was to stand, with the result that there are portions that meet at awkward angles. In fact, there was no definite planning at the beginning. Various parts were taken in hand at different times and treated on their individual merits, and the whole afterwards reconciled as might most suitably be contrived.[26]

THE NUT WALK AND PERGOLA

The Nut Walk, which runs from just below the north side of the house to the Pergola, represents one of those "awkward angles." It was probably installed in the mid-1890's, judging from the maturity of the trees in a photograph taken in 1907 (Photograph 26). It consisted of double staggered rows of arching cob-nuts (*Corylus maxima*) on each side of a path, planted ten feet apart. The double rows were arranged so that the back rows showed through between the front ones, which stood four feet back from the path.[27] In the spring the borders underneath were planted with hellebores on one side and primroses, blooming slightly later, on the other side. In the summer the Nut Walk provided a shady walkway to the small summerhouse at the end. Later in the year tubs of hydrangea were placed on stone pads. Upon exiting from the Pergola at the end of the shady Nut Walk one came out upon the dazzling Main Flower Border.

Adjacent to the Nut Walk was a special area in the garden, enclosed by yew and named by a visitor the Cenotaph of Sigismunda for its "monumental simplicity"[28] (Photograph 25). A simple seat was placed under a magnificent weeping birch tree providing shelter on a sunny afternoon. The cavernous enclosure was planted with mulleins that bloomed in the summer and were replaced with tubs of hydrangea in the autumn, as in the image.

The Pergola at Munstead Wood is a simple but effective garden structure that was built with square brick piers and oak beams. By the late 1890's, a few short years after being built, it was covered with some of Jekyll's favorite vines and climbers, including jasmine, Virginia creeper, and wisteria (Photograph 27). Jekyll discovered the pergola as an interesting garden element in her early travels to Italy and had already incorporated one into the garden at Munstead House. It became a standard feature in gardens of their partnership, each pergola being an essay by Lutyens in refinement of form and siting. At one time another, more rustic, pergola was located in the Kitchen Garden for displaying gourds and their bold foliage.

THE PAVED COURT AND TANK GARDEN

The boldest and most formal part of the design scheme at Munstead Wood is the paved area in the north courtyard of the house, known as the Paved Court, with its adjacent Tank Garden. Jekyll acknowledged that this was the one area in the design for which there was a "definite plan."[29] The Paved Court and Tank Garden were laid out at the same time the house was designed to form a built link between the house and the garden. The courtyard was constructed of the same local Bargate

stone as the house (Photograph 68), and lies between the two north wings, framed by the half-timbered long gallery upstairs. The Tank Garden, which consists of a square pool flanked by two square paved areas, is asymetrically positioned at the end of the Paved Court. A plan dated May 12, 1896, and an undated watercolor plan and garden elevation, both by Lutyens,[30] show two versions of how he attempted to reconcile an "awkward angle" created by the existing paths leading to the garden. Both drawings locate the paths and clearly mark the position of the Cenotaph, without detailing the Nut Walk, which already appears on the 1893 plan.

The Paved Court (Photograph 29) is a shady area that in Jekyll's time featured a fine *Clematis montana* that "riots over the wall facing east and up over the edge of the roof."[31] In the recess underneath the long gallery and the clematis swag an early example of one of Lutyens' unpainted wooden benches can be seen. The shaded courtyard provided Jekyll with additional display areas for bold groupings of flowers and foliage in tubs that were changed throughout the season. In the summer she set out lilies in plain pots, and placed hostas in front in better containers (Photograph 31). Later in the season, as the hosta leaves suffered inevitable deterioration from insects, she set out tubs of hydrangea.

More bold groupings of tub plants decorated the steps and paved areas of the sunny Tank Garden. Cannas and lilies (Photograph 32) provided a startling combination framed by dark green yew hedging, while boxwood clipped into spheres embellished the eight corners of the paved squares flanking the pool (Photograph 33). Ferns in tubs on the pavement, as well as on the ledges inside the pool itself, provided additional green foliage. Planters filled with *Francoa ramosa* (maiden's wreath) lined the top edge of the pool in place of railings (Photograph 34).

TERRACE PLANTINGS

On the opposite side of the house from the Tank Garden, a long south-facing terrace opens out onto the lawn and shrubbery edges (Photograph 35). As the property slopes gradually down to the north, shallow steps lead up from the south terrace to the lawn, whereas in the Tank Garden the steps lead down to the lawn. Soon after the house was finished in 1897,[32] Jekyll began planting the terraces. Along the sunny south side of the house she designed a narrow border with rosemary and China roses. A hardy fig vine, similar to another one on the loft building, was trained along the house and encouraged to grow over the workshop windows. Another narrow border separated the earthen terrace from the lawn (Photograph 36). To accommodate the grade change between the shallow steps on

the south terrace and drywalling on the west side of the house, Jekyll planted the top of the wall with Scotch briar roses and created a peat bed filled with andromeda at the bottom. While waiting for the Scotch briars to mature, Jekyll interplanted with mullein. On either side of the steps she set out more planters filled with *Francoa ramosa*.

SHRUBBERY EDGES AND WOODLAND PLANTINGS

Jekyll's design sense is further revealed in a sequence of photographs taken about 1906 (Photographs 36–38), recording her love of "pretty incidents" in plantings at shrubbery edges. Lilies and ferns defined the transition from lawn to woodland and provided a viewpoint into the woods from the windows of the house. She writes: "Where the wood comes nearest the house with only lawn between, it is well to have a grouping of hardy Ferns and Lilies."[33] The placement of the lilies near the beginning of one of the wide paths also indicates directional movement within the garden. Most of the shrubbery areas in the lawn near the house were "finished" with groupings of shrubbery-edge plantings. Although she used familiar plants Jekyll sometimes produced unusual planting combinations. In one case she used clouds of gypsophila interplanted with bergenia (Photograph 39), and in another she combined hostas and ferns with *Olearia gunni* (*gunniana*), and edged it with bergenia foliage (Photograph 40).

In the rougher ground surrounding the house, Jekyll was able to demonstrate another facet of her creative use of plants. Here she created informal drifts of self-seeding woodland plants. It was in these areas that she was obviously much influenced by the teachings of William Robinson, whose book on wild gardening was first published in 1870.[34] Robinson advocated the use of spring bulbs and plantings in shrubbery edges as well as the development of areas set aside for informal groupings of native and exotic wild flowers. He even promoted the radical idea of leaving meadows of wild flowers near the house almost completely unmown. Jekyll wrote:

> Often in the outer regions of a garden there is a roughish place that is without any special feature, and where no attempt has been made towards any ornamental planting. Even if the place is overgrown with grass and weeds, and it is not desired to keep it cleanly cultivated, a few gashes through the growth here and there with a heavy hoe or mattock, and a little Poppy seed sprinkled, may result in a garden picture of a high degree of beauty.[35] [Photograph 41]

Jekyll came upon a group of wild foxgloves in the woodland and carefully selected one that she later developed as "Munstead White." In July 1888 she recorded a group of foxglove and ferns "in half-hidden glades of woodland mystery"[36] (Photograph 42).

Jekyll was first and foremost an accomplished plantswoman whose well-trained painter's eyes gave her the ability to combine and compose her plants in a manner that reflected unsurpassed ingenuity with color and texture. On a more personal level, she was obviously overjoyed with the cultural success of a difficult plant. Her books and articles detail her trials with sandy Surrey soil and her inability to successfully grow lilies. For a number of years she was fascinated with the so-called giant lily (*Cardiocrinum giganteum*), which grows well in Scottish gardens but is a bit tricky in southern soils. She must have discovered something that made the heavy-feeders happy,[37] because as early as 1888 she began recording a solid grouping that she had established somewhere on the Munstead property. What prompted her to dress up one of her gardeners in a Sussex monk's habit to stand next to the clump (Photograph 43) reveals the lighter side of her personality that instantly appealed to her many artistic and musical friends, including Lutyens, who dubbed her, "Aunt Bumps, Mother of All Bulbs."

THE SEASONS OF MUNSTEAD WOOD

1888–1914

Munstead Wood, Gertrude Jekyll's own garden in Surrey,
was the location of her ongoing experiments in planting design,
horticultural studies, and photography. Many of the
images in Jekyll's photo-notebooks detail
the evolution of her garden.

The Seasons of Munstead Wood, 1893-1916

This plan shows the buildings and garden areas of most of the Munstead Wood site as they appeared in Gertrude Jekyll's time. It was prepared with information compiled from Jekyll's plans for gardens and borders, Lutyens' plan of 1893, and an Ordnance Survey Map of 1916. Dotted lines have been used to designate the approximate location of those gardens and areas for which Jekyll provided no plans.

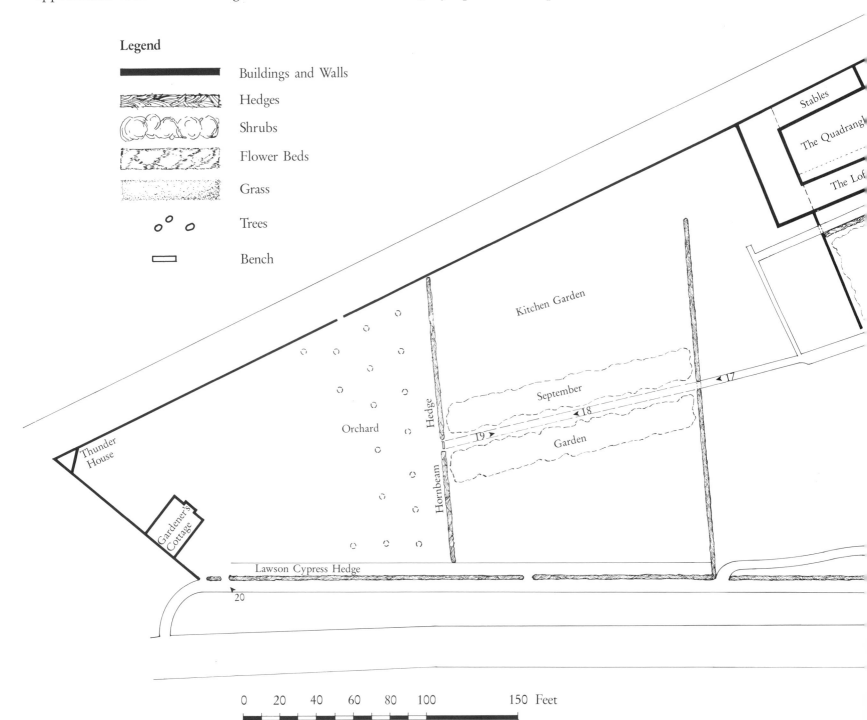

Legend

Buildings and Walls

Hedges

Shrubs

Flower Beds

Grass

Trees

Bench

Stables

The Quadrang

The Lof

Kitchen Garden

Hedge

September

Garden

Orchard

Hornbeam

Thunder House

Gardener's Cottage

Lawson Cypress Hedge

17

18

19

20

0 20 40 60 80 100 150 Feet

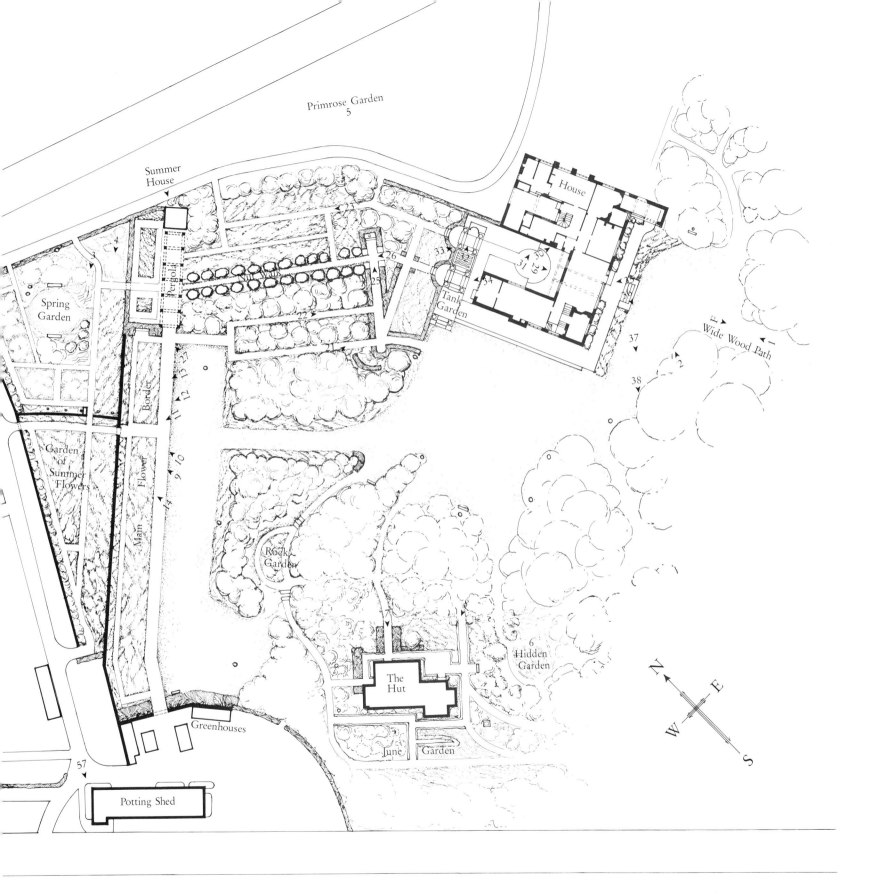

Primrose Garden
5

Summer House

House

Spring Garden

4

3

Pergola

26

25

33

32

31 30
29

5A

37

F

Wide Wood Path

38

2

Tank Garden

Nut Walk

12 13 17

Border

11

Main Flower

Garden of Summer Flowers

9 10

14

Rock Garden

6
Hidden Garden

N

E

W

S

The Hut

Greenhouses

June Garden

57

Potting Shed

e numbers above correspond with the numbered photographs in
book. The arrows indicate photographer's vantage point.

Drawn by Kate Collins, Dodie Finlayson, and Marsha Topham,
March 1988, and revised by Marsha Topham, July 1988.

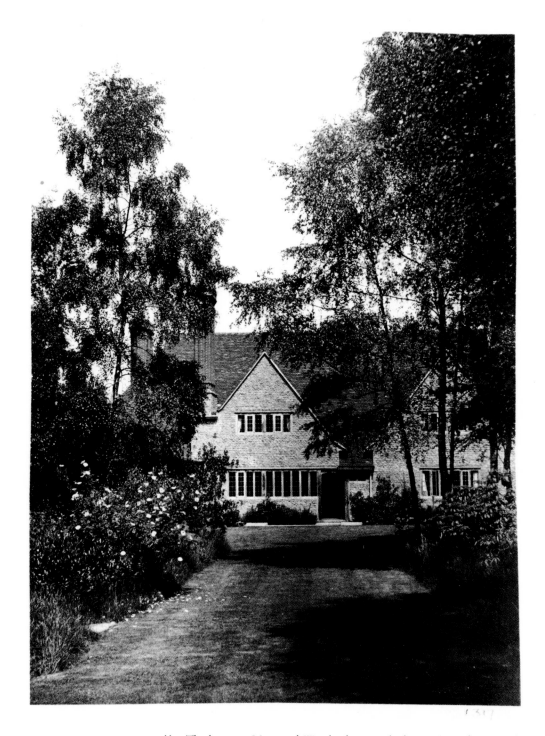

1. "THE HOUSE FROM THE COPSE" · The house at Munstead Wood, photographed sometime after completion in 1897, was designed by Edwin Lutyens (1869–1944) as an interpretation of Surrey vernacular architecture. Jekyll's new house was carefully sited in a chestnut copse to complement her already existing woodland garden and was designed to look as though it had always been there.

2. (UNCAPTIONED) • A glimpse of the house from the woodland plantings at the edge of the lawn illustrates Jekyll's use of simple plantings and careful tree selections to create what she called her most successful "garden pictures."

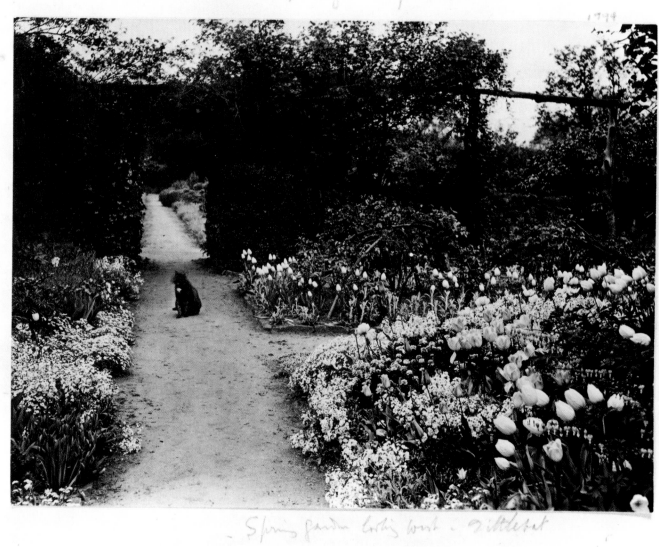

3. "SPRING GARDEN LOOKING WEST — TITTLEBAT" • Two images, probably taken in 1907, show a portion of Jekyll's garden that was set aside for spring-blooming plants. Drifts of bulbs and flowering plants were framed by oak and holly trees on the woodland edge and by yew hedges and two walls on the garden side.

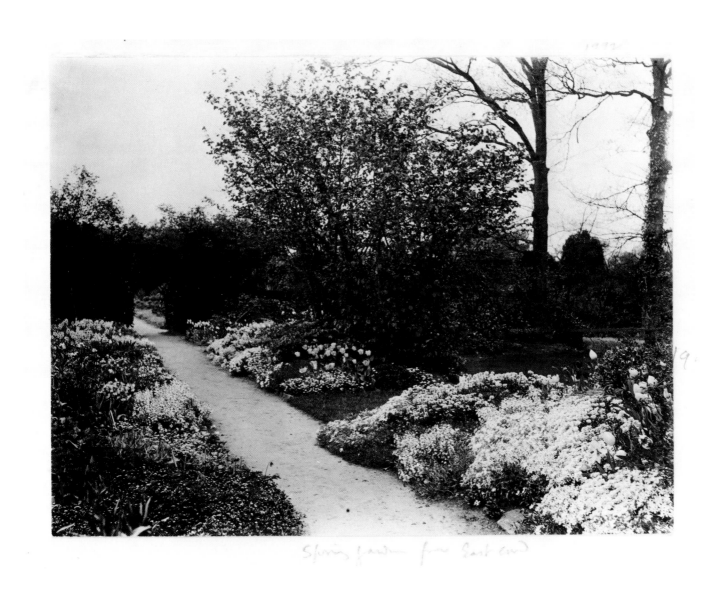

Spring garden from East end

4. ''SPRING GARDEN FROM EAST END'' ‧ The main border of the Spring Garden included carefully graded color masses, ranging from large drifts of pale colors in the foreground to deeper colors in the background. Though the principal bloom period was April through mid-May, clematis trained over the archway and plantings of tree peonies provided interest at other times.

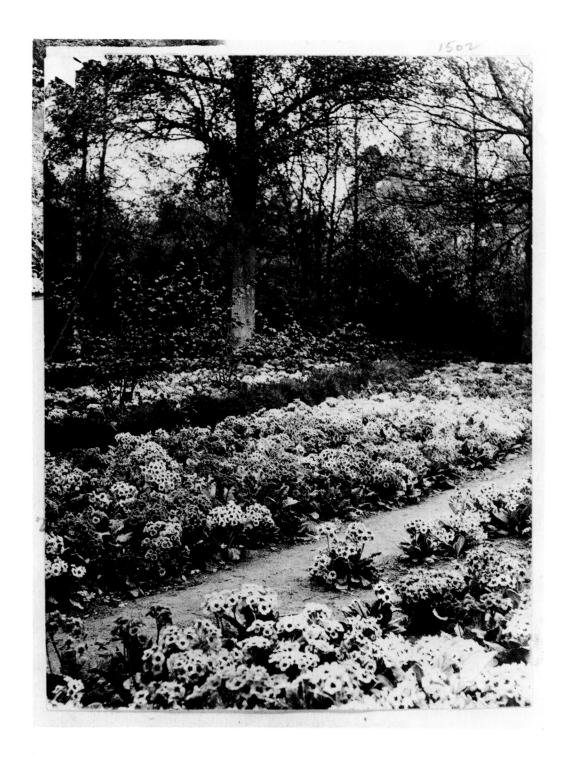

5. "*PRIMROSE GARDEN*" • A woodland area near the house, shaded by chestnuts and hazels, was set aside for Jekyll's late-April-blooming primroses, shown here in a photograph from the early 1900's. The original 'Munstead Bunch' primrose was found by Jekyll in a local cottage garden in the early 1870's, and she bred primroses for over fifty years.

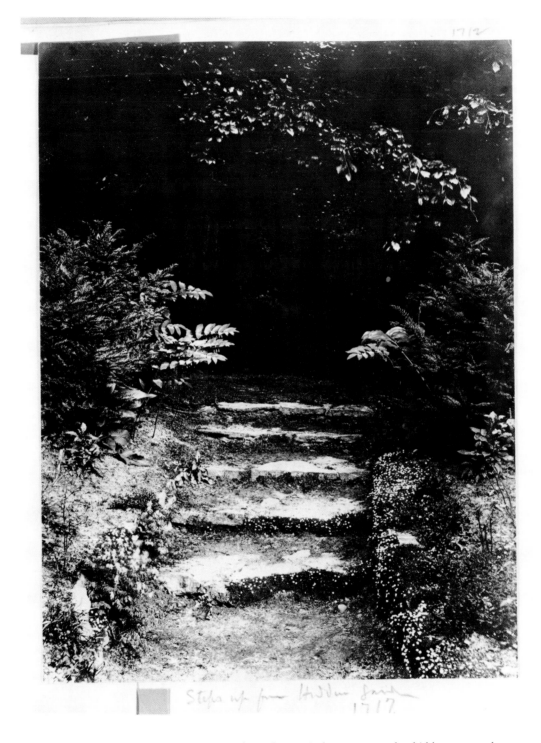

6. "STEPS UP FROM HIDDEN GARDEN" · In the early 1900's there was a garden hidden among the surrounding hollies and yews that bloomed from late May to mid-June. It lasted only a few years, as the available light diminished when the shrubbery matured, and it was replaced by a shade-loving fern garden.

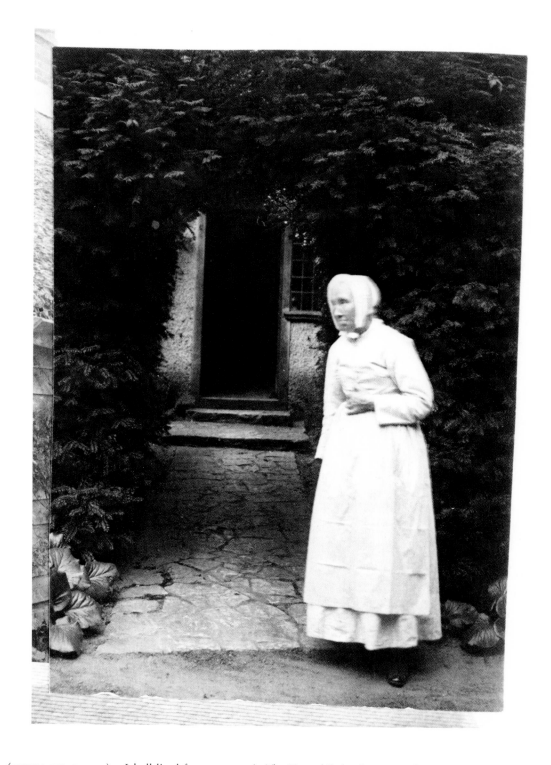

7 . (UNCAPTIONED) · Jekyll lived for two years in The Hut while her house was being built nearby. The Hut was designed and built in 1893–94 by Lutyens as a recreation of a tile-hung Surrey cottage.

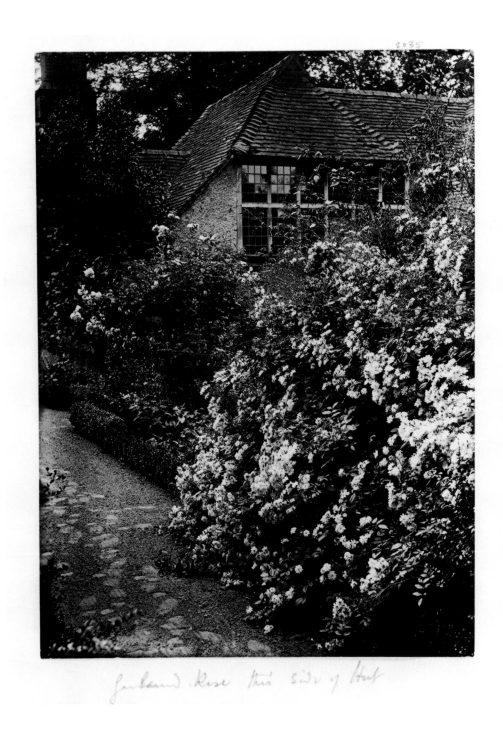

Garland Rose this side of Hut

8. "GARLAND ROSE THIS SIDE OF HUT" · While living in The Hut, located only eighty yards from the site of the main house, Jekyll could keep an eye on the construction of the house and tend the June Garden that surrounded it.

The Main Flower Border, 200 feet long by 14 feet wide, was designed for July to October interest, although the chief bloom period was mid to late summer. It was in this long border that Jekyll produced some of her most spectacular color studies, based in part on her training as an artist and landscape painter. The carefully gradated colors ranged from pale yellows, whites, and pinks or blues at each end, through cooler and deeper tones toward the middle, to saturated orange and scarlet at the center.

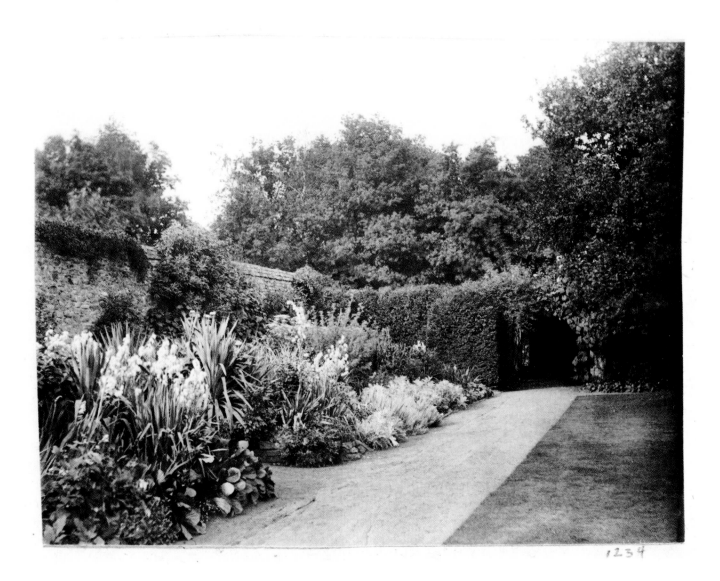

9. ''END OF FLOWER-BORDER'' · An early view of the border, published in her book *Wood and Garden* in 1899, shows the enclosure at the back with an 11-foot-high sandstone wall clad with numerous vines and evergreen shrubs trained as climbers.

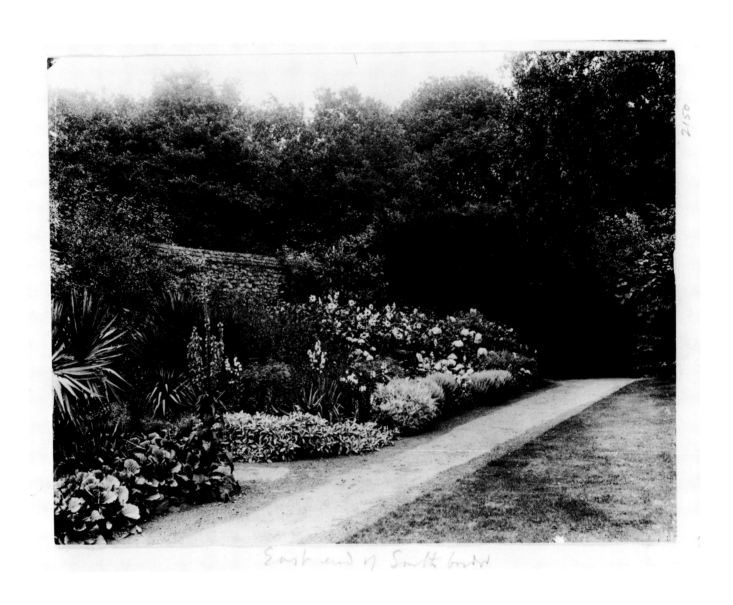

10. "EAST END OF SOUTH BORDER" · This photograph taken in August 1914 shows that the basic planting concept changed very little when compared with Photograph 9.

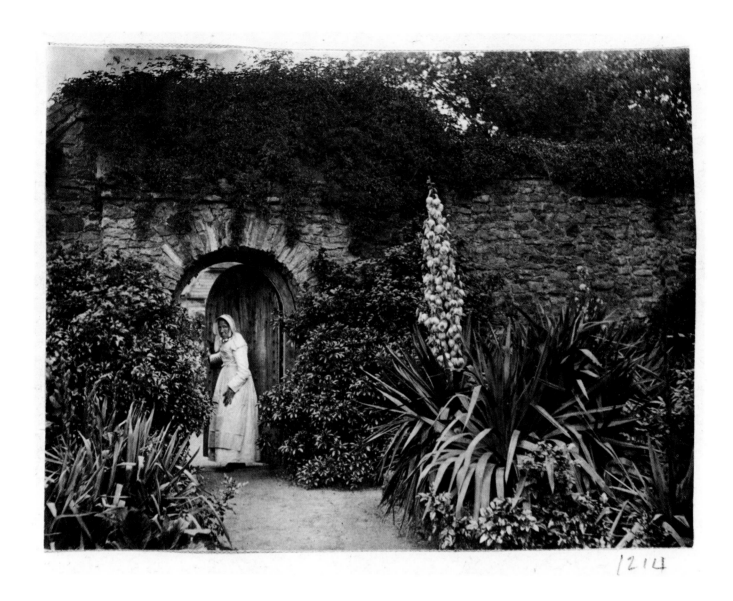

1214

11. "PATHWAY ACROSS THE SOUTH BORDER IN JULY" • Another early view of the border, taken just before Photograph 9, shows Jekyll's housekeeper standing at the south door in the garden wall, with a glimpse of the Quadrangle buildings and gardens beyond. The pathway divides the east and west ends of the Main Flower Border. At the right just behind the flowering yucca can be seen the access path for maintenance at the back.

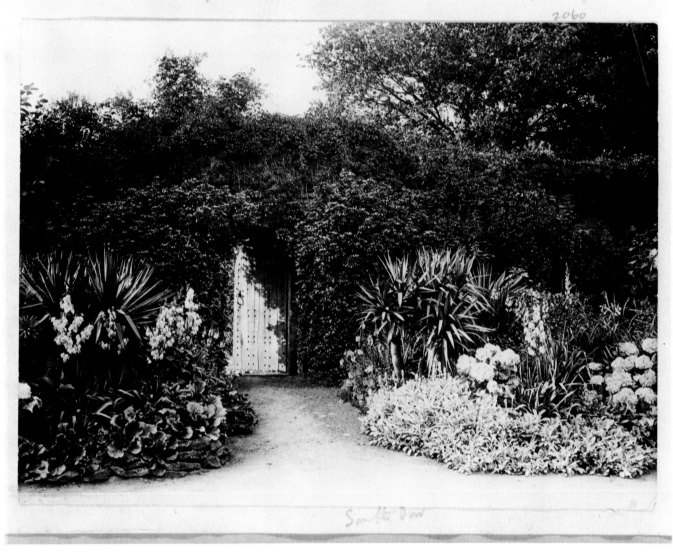

12. "SOUTH DOOR" • A late summer image shows that the yuccas have been cut back to keep their height in proper scale in the border by 1908, when this photograph appeared in Jekyll's most popular book, *Colour in the Flower Garden*. The drama of the composition has been created by combining bold plants, such as yucca, bergenia, stachys, and hydrangeas.

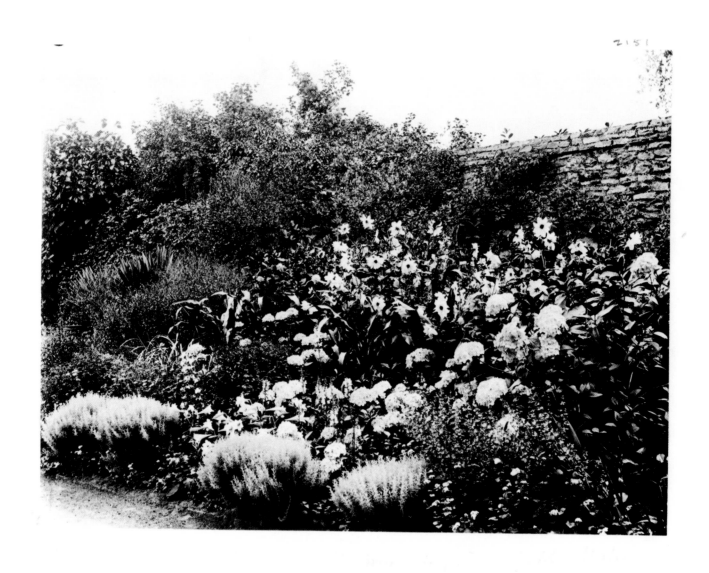

13. "END OF SOUTH BORDER LOOKING WEST. HYDRANGEAS, DALHIAS, WISTARIA" • Jekyll recorded the last image of her garden in the photo-notebooks on August 14, 1914, in one of the few dated photographs. This detail, taken at the same time of year as the previous photograph, shows dalhias and hydrangeas, with clumps of santolina at the front edge.

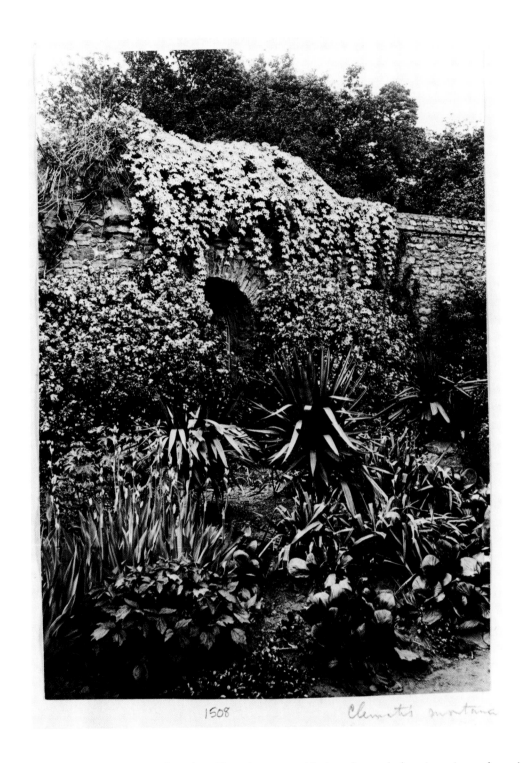

1508 Clematis montana

14. "CLEMATIS MONTANA" · June-flowering *Clematis montana* blankets the south door in an image from the early 1900's.

The work buildings at Munstead Wood, known as the Quadrangle, consisted of stables, work sheds, and a stone-stepped loft. The grounds that surrounded these buildings were the setting for additional gardens, including the kitchen and reserve gardens, and numerous borders with gray foliage.

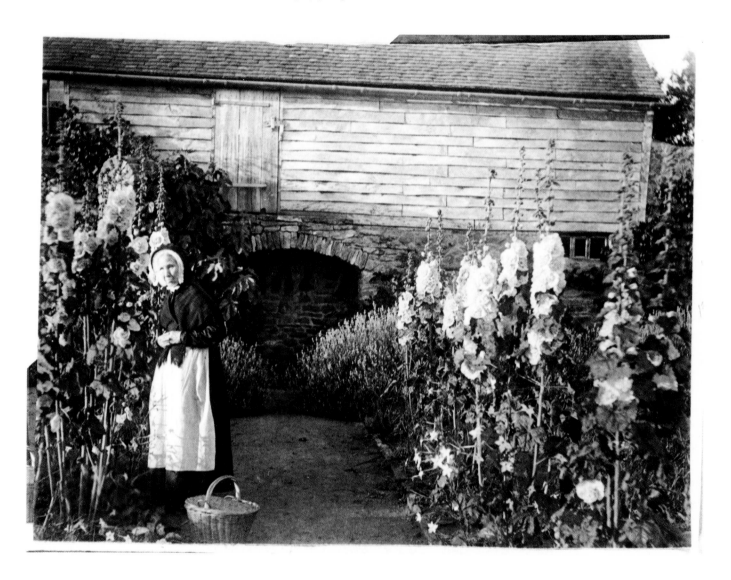

15. "HOLLYHOCK PINK BEAUTY" · In this image from the late 1890's the housekeeper is picturesquely posed among the hollyhocks against the wood-clad loft building. The fine-textured lavender hedges in the background define the garden edges. The pathways in these gardens were lined with gray-foliaged plants, such as stachys, echinops, and nepeta.

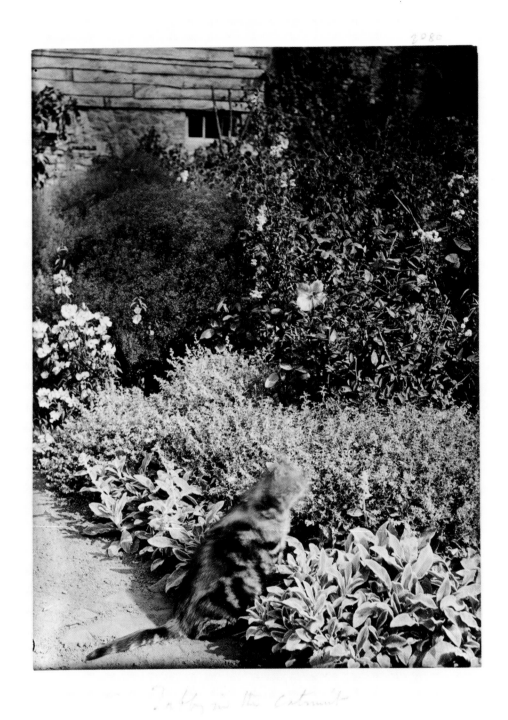

16. "TABBY IN THE CATMINT" · A photograph probably taken in midsummer 1907 or 1908 shows a detail of the same pathway with a border of plants with gray foliage that included nepeta.

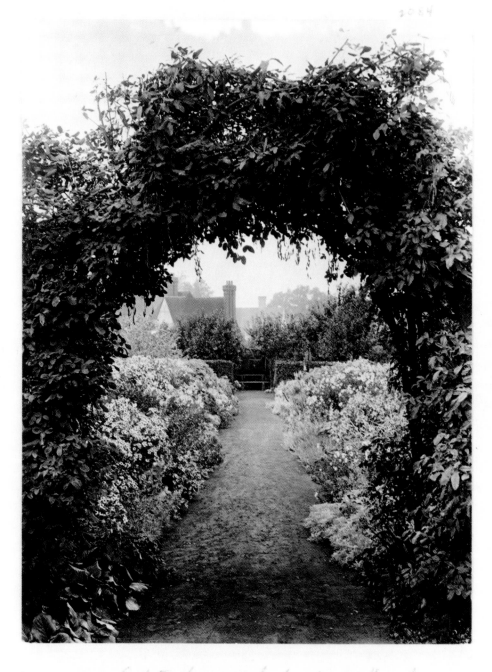

The September Garden, shown in a series of photographs published in 1908, was located on either side of a pathway near the Quadrangle. It consisted of some of the numerous gray or gray and pink borders that Jekyll designed to complement her work buildings. The summer borders that she created in this area of the garden at Munstead Wood were less formal than the designed garden spaces near the main house.

17. "SEPTEMBER BORDER LOOKING DOWN THROUGH LABURNUM ARCH" · A garden entry gate is created with pleached laburnum trees that frame the Gardener's Cottage in the distance.

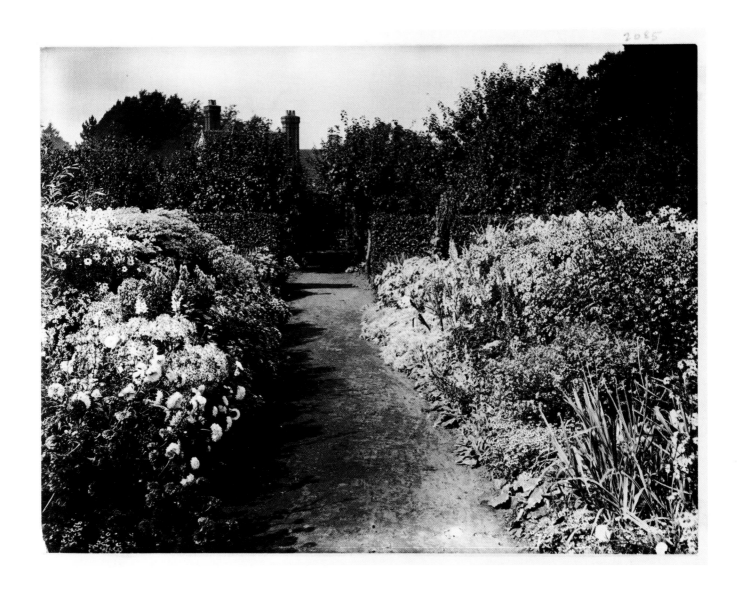

18. ''SEPTEMBER BORDERS LOOKING DOWN'' · The September Garden was also known as the Grey Garden, as it consisted of borders of gray foliage that highlighted the September-blooming asters. These borders were backed with hornbeam hedges trimmed at $5^{1}/_{2}$ feet.

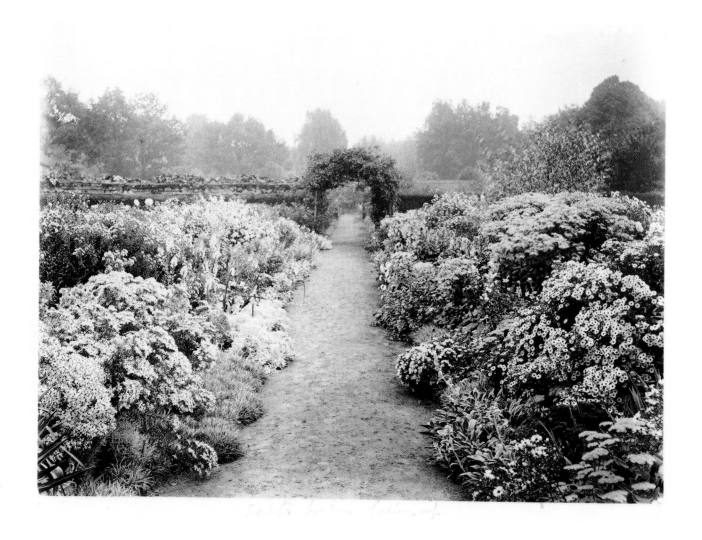

19. "SEPTEMBER BORDERS LOOKING UP" · The double gray borders consisted of artemisia, lyme grass, and stachys, with drifts of white pinks, phlomis, sedum, Japanese anemones, dalhias, and *Pyrethrum uliginosum*. The gray bordering formed a groundwork for the display of drifts of pale yellow and pale pink flowers. The soil of Munstead Wood was poor and sandy, and Jekyll worked to select plants that would do well in it and then she arranged them in striking combinations.

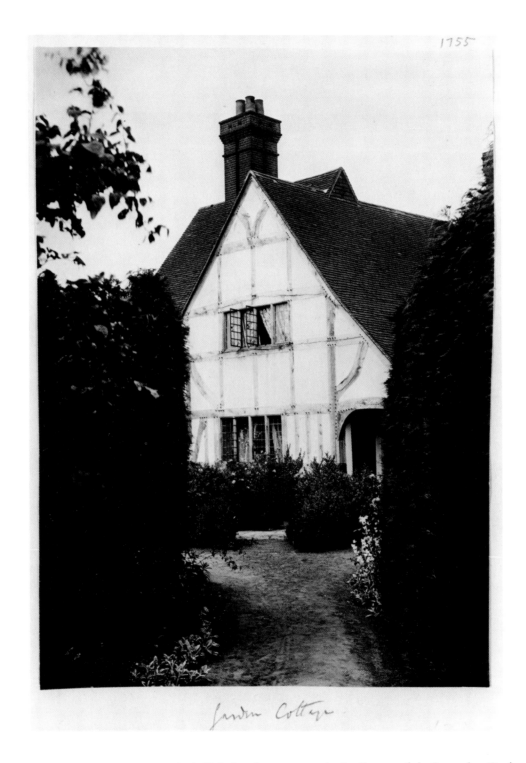

1755

Garden Cottage

20. "GARDENER'S COTTAGE" · The half-timbered cottage seen in the distance of the September Garden view was designed by Lutyens in 1893 and built in 1894 for Jekyll's Swiss gardener, Albert Zumbach. It is located at the far end of the property in the fruit orchard.

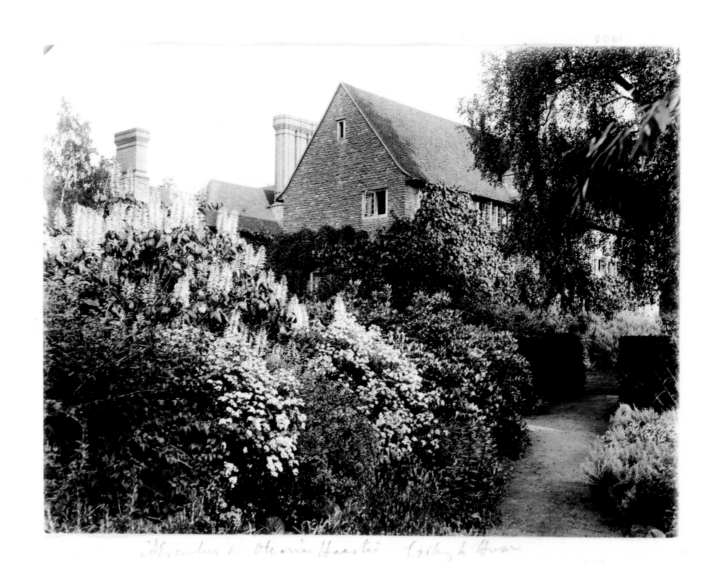

21. "AESCULUS AND OLEARIA HAASTII LOOKING TO HOUSE" • At the end of the garden season, the October-flowering plants brought color closer to the house. Autumn-blooming shrubs can be seen in the planted areas near the main house. Well-developed climbers on the house and more mature plantings are evident in this photograph taken about ten years after the house was built.

22. (UNCAPTIONED) · An earlier view from the late 1890's of the area shown in the previous photograph. Taken from a slightly different angle, this photograph shows Jekyll's garden workshop door on the south wing of the house.

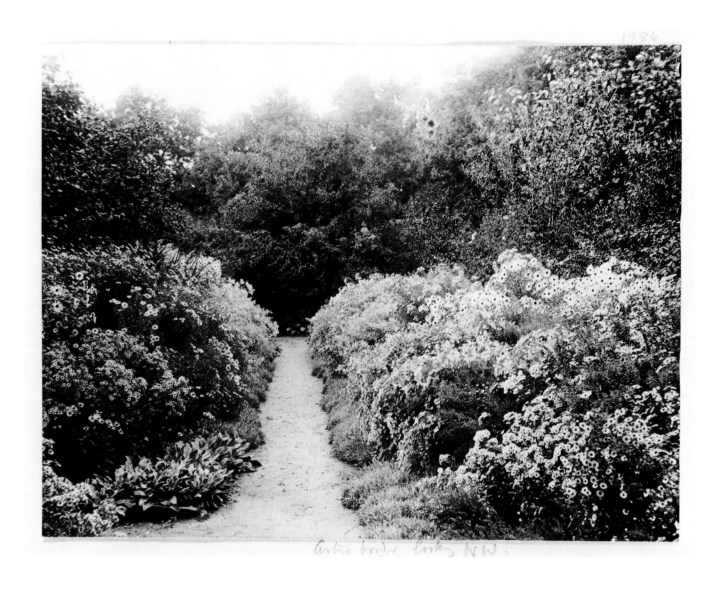

1906

Aster border looking NW.

23. "ASTER BORDER LOOKING NW" • Jekyll noted that careful staking of October-blooming Michaelmas daisies was required. This border near the house, and visible from the upstairs gallery, included asters of cool coloring, with *Pyrethrum* daisies, stachys, and lyme grass. The double aster borders are enclosed on the garden end by the vine-clad Pergola. This image was probably taken in 1906.

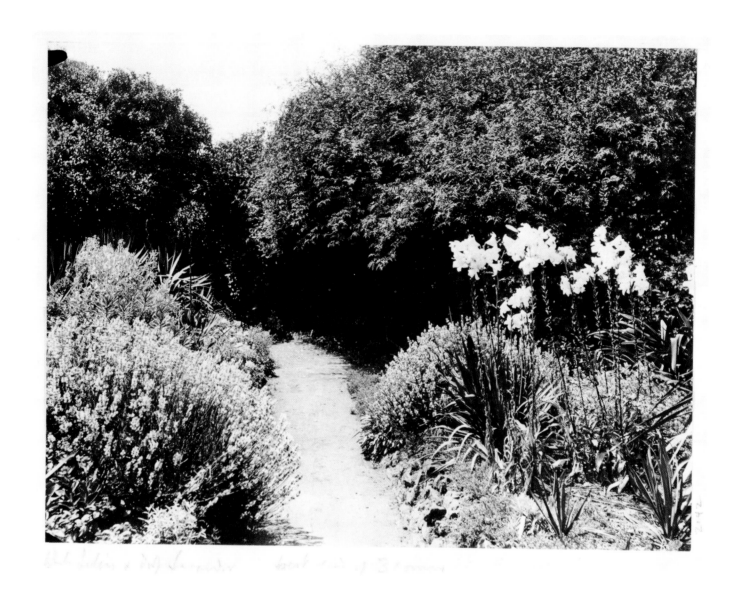

24. "WHITE LILIES AND DWARF LAVENDER. WEST END OF THREE CORNERS" • In a photograph probably taken in 1914, the extent to which Jekyll's favorite plants recurred in the plantings at Munstead Wood can be seen.

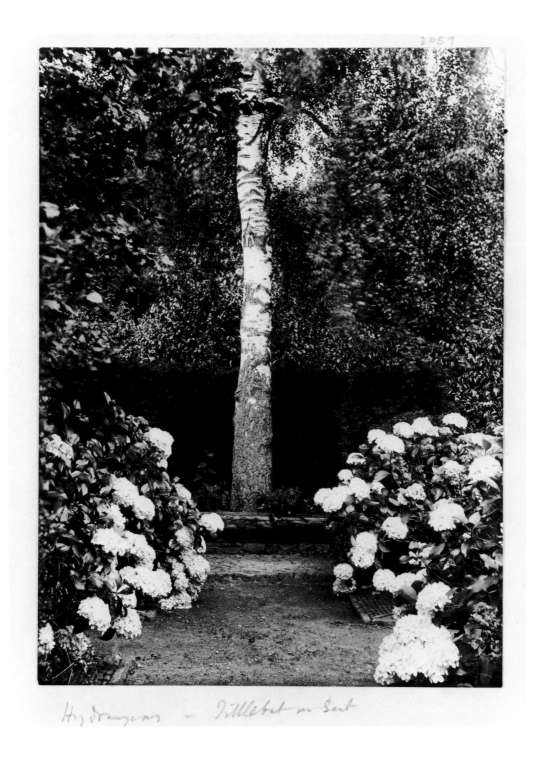

Hydrangeas — Tittlebat in Seat [handwritten caption]

25. "HYDRANGEAS—TITTLEBAT IN SEAT. AUGUST 27, 1907" · A small seating area enclosed with yew and sheltered
under an existing weeping birch offered the full benefit of the afternoon sun. The seat was named
the Cenotaph of Sigismunda for its "monumental simplicity."

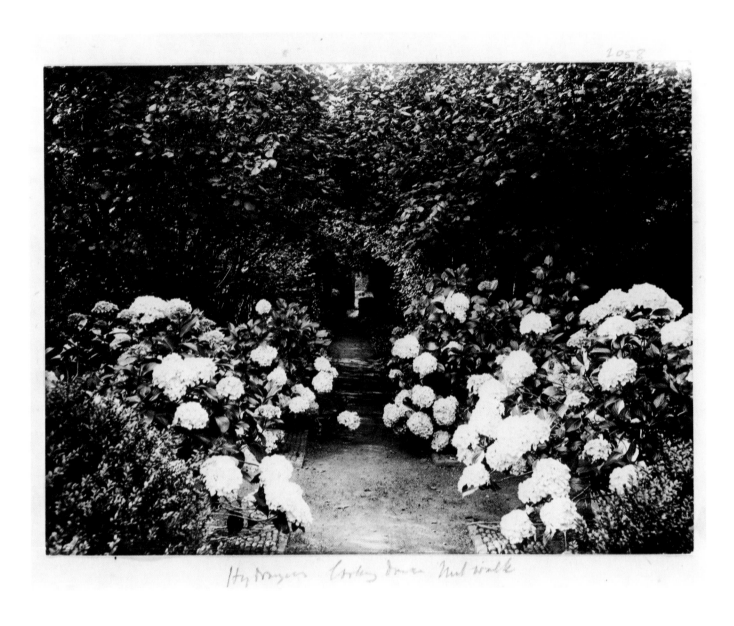

26. "HYDRANGEAS LOOKING DOWN NUT WALK" · Jekyll's interest in the sequencing of garden spaces is evident in this view down the Nut Walk to the Pergola. In the spring the borders were underplanted with primroses on one side and hellebores on the other.

One of the first built elements in the garden at Munstead Wood, the Pergola was designed and constructed in 1893. Shade and darkness under the structure were in sharp contrast to the sunny Main Flower Border seen upon exiting the Pergola. The pergola was a feature that appealed to Jekyll during her earlier travels to Italy, and it appeared in a number of her subsequent garden designs with Lutyens.

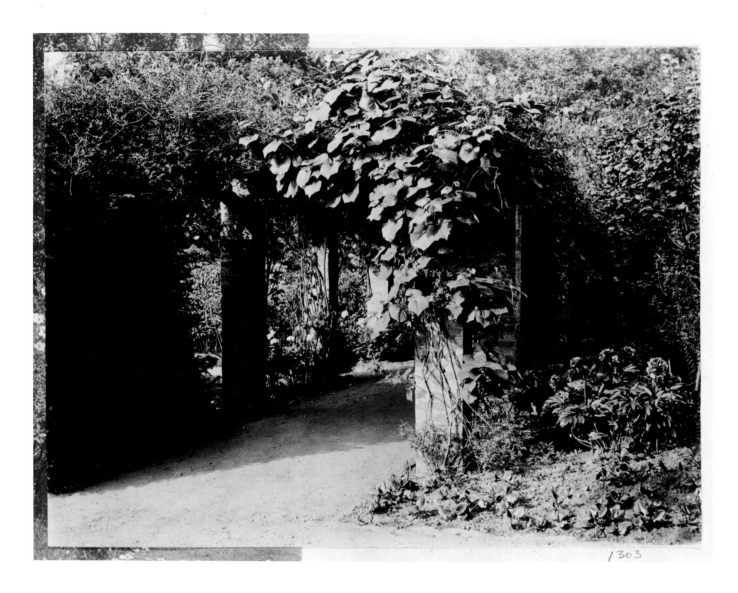

27. (UNCAPTIONED) · This view taken in the late 1890's shows the rapid growth of some of Jekyll's preferred pergola plants, including jasmine, Virginia creeper, and wisteria. The brick piers in her pergola are framed with sturdy oak beams. A rough pergola in another part of the garden displayed gourds and their bold foliage.

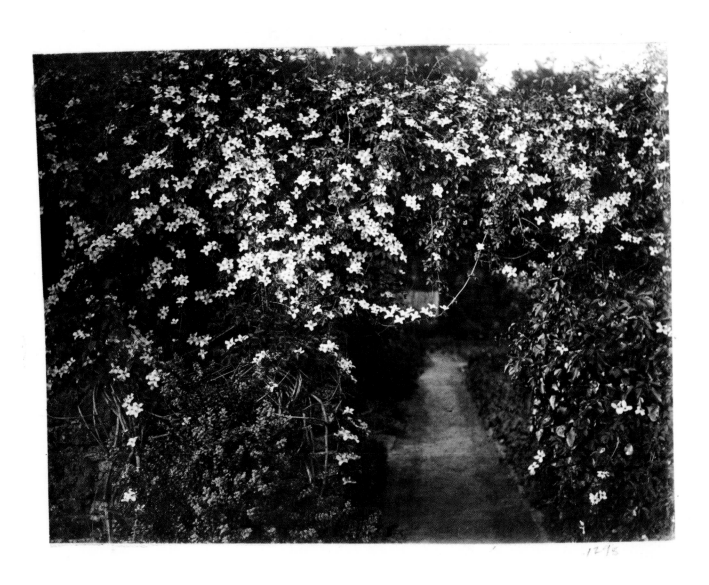

28. (UNCAPTIONED) · In addition to pergolas, Jekyll used vines as part of treillage to informally cover walkways. Vines offered Jekyll the advantage of providing shade for compact areas without the competition for light and root space that trees would create.

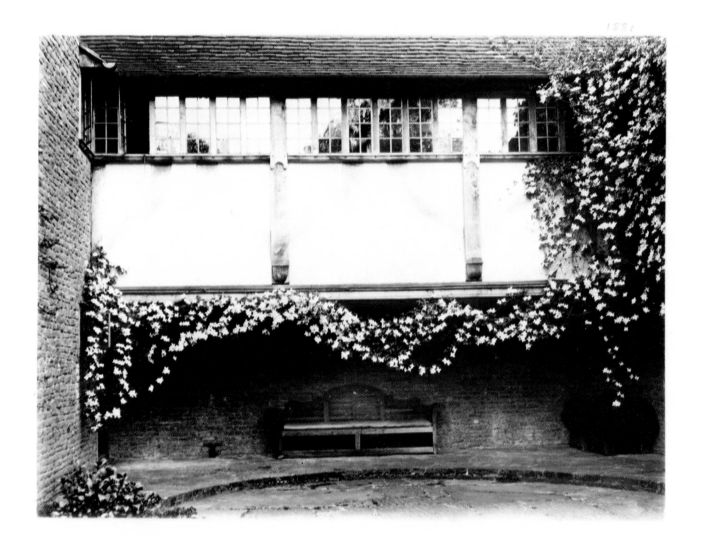

29. "CLEMATIS MONTANA TRAINED AS GARLANDS" · The Paved Court, which was laid out when Lutyens designed the house, lies between the two north wings and is framed by the half-timbered long gallery. The bench, which was designed by Lutyens, can be seen in the recess under the clematis in this photograph, probably taken in early June 1905.

30. "LILIUM SPECIOSUM, HYDRANGEA AND FUNKIA" · Bold groupings of flowers and foliage in tubs were used along the edges of the shaded courtyard and changed throughout the season, as seen in this photograph published in 1908.

3 1 . (UNCAPTIONED) · In an earlier photograph from the late 1890's, the clematis has not yet reached the left wall and double window of the house. The better pots were placed in the foreground of the courtyard display, while more utilitarian ones were hidden in the back among the hosta foliage.

The Tank Garden is positioned between the Paved Court and the entrance to the pleasure garden. The series of gentle steps for the terrain that slopes to the north provided easy access and also created display areas for additional plants in tubs, as did the shallow shelves just inside the edges of the pool.

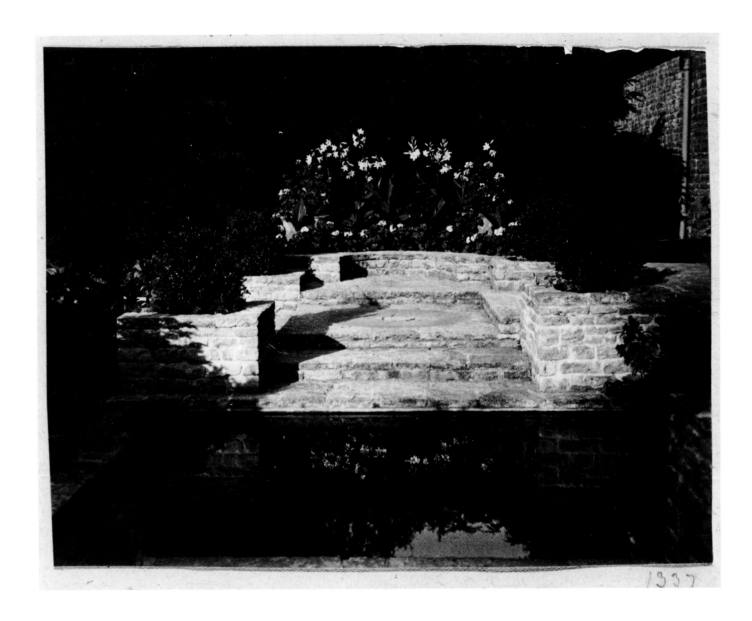

32. "LILIES AND CANNAS IN THE TANK-GARDEN" · The stone Tank Garden was cleverly designed to lead from the Paved Court to two garden paths: the October Michaelmas daisy border and the Nut Walk. Asymetrical double squares flank the pool. This photograph shows the area soon after completion.

"This is an Artesian Well"! 1364

33. "THIS IS AN ARTESIAN WELL!" · In a view taken in the summer of 1899, the hanging ferns on
the tank shelves contrast with the adjacent formally clipped boxwood globes.

Francoa by Tank

34. "FRANCOA BY TANK" • The autumn-blooming shrubs from Photograph 21 can be seen in the background in this view published in 1908. The maiden's wreath (*Francoa*) in the planters mark the grade change at the tank edge where there are no railings. The planting of groups of four boxwood globes around the tank restates the formality of this area.

35. "MAIDEN'S WREATH (FRANCOA RAMOSA)" · On the opposite side of the house from the Tank Garden, a long south-facing terrace opened out onto the lawn and shrubbery edges. Jekyll planted this dry, sunny border with rosemary and China roses, and near the adjacent shallow steps leading from the earthen terrace to the lawn and woodland edge she set Scotch briar roses interplanted with mullein. A mature grape vine laden with fruit was trained along the south face of the house.

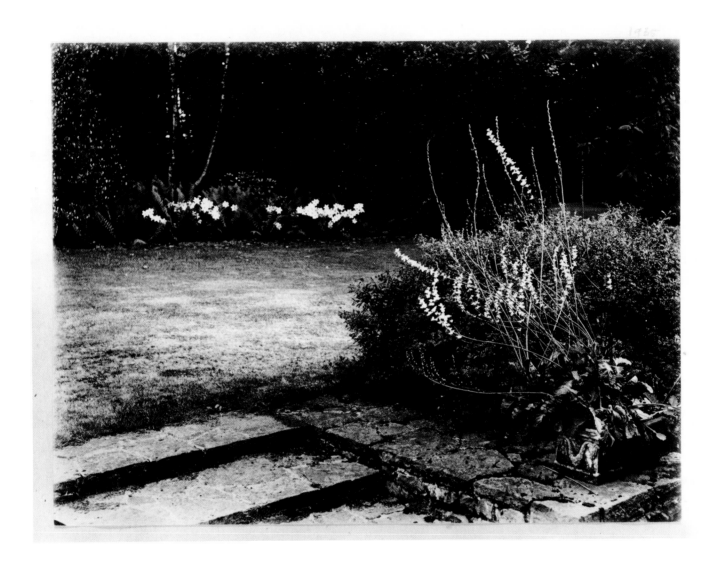

36. "THE NARROW SOUTH LAWN" · A sequence of photographs taken about 1906 illustrates Jekyll's love of "pretty incidents."

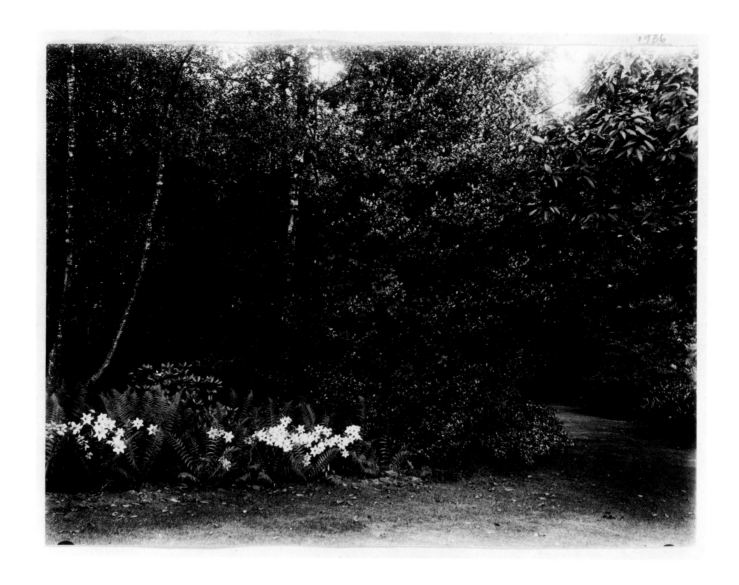

37 · "LILIES AND FERNS AT THE WOOD EDGE NEAR LAWN" · It appears that with this series of images Jekyll was recording the placement of plants to offer directional clues to movement within the garden.

38. "FERNS AND LILIES AT A SHRUBBERY EDGE NEXT THE WOODS" • In 1908 Jekyll wrote, "Where the wood comes nearest the house with only lawn between, it is well to have a grouping of hardy Ferns and Lilies."

39. "GYPSOPHILA AND MEGASEA AT SHRUBBERY EDGE" · Some of the edges of shrubbery borders were planted with familiar plants, but in unusual combinations.

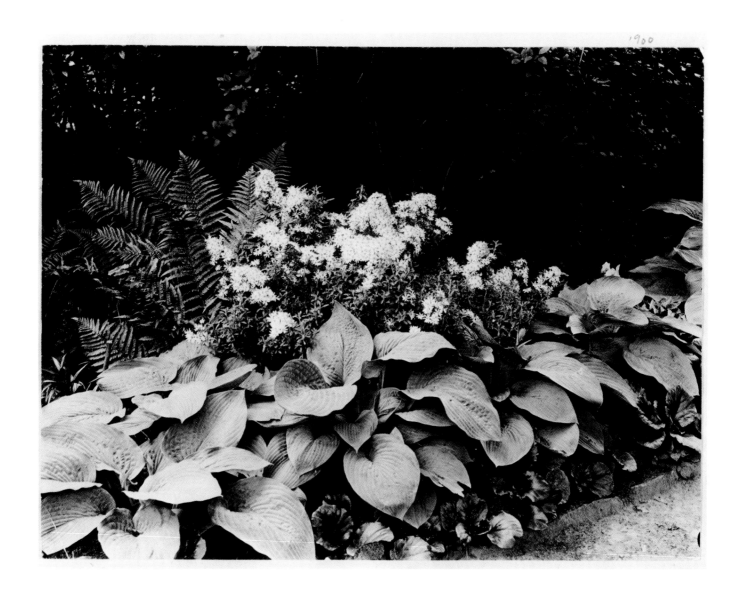

1900

40. "OLEARIA GUNNI, FERN AND FUNKIA AT A SHRUBBERY EDGE" · The contrast of the bold foliage of hostas and bergenias, against a background of feathery ferns and the tiny daisy-like flowers of *Olearia gunniana*, makes a striking edging.

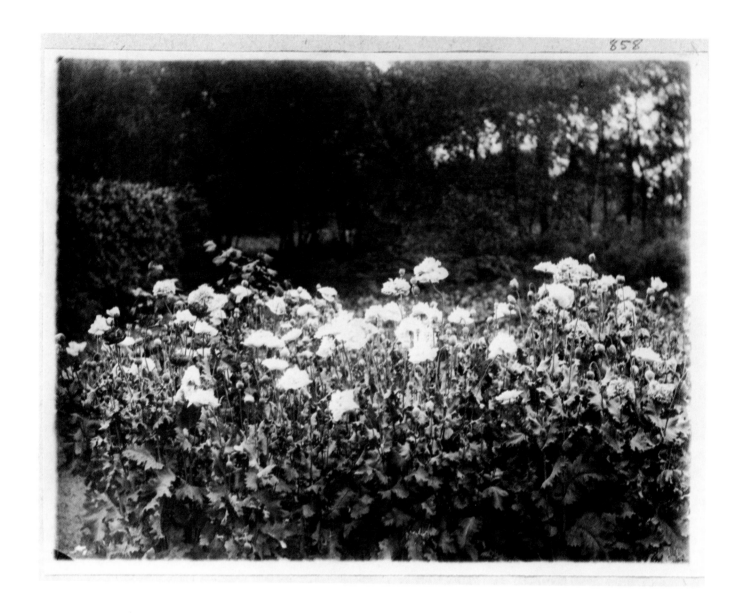

41. ''POPPIES IN TRIAL GARDEN'' · In the late 1880's Jekyll was actively creating plantings around Munstead Wood, although she was still living across the road at Munstead House. In addition to plantings of traditional woodland plants, she also raised annuals such as opium poppies at the edge of the woods in rough ground unsuited for more structured designs.

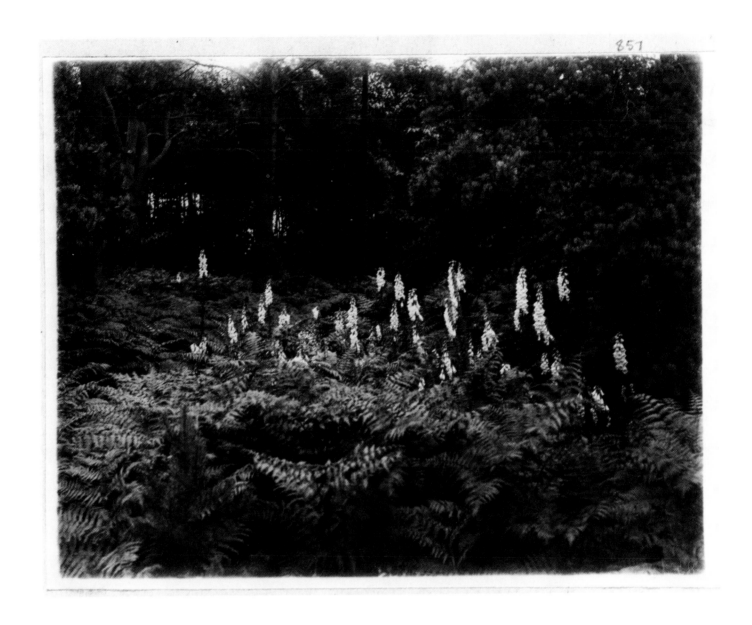

42. "WHITE FOXGLOVE AND FERN" · Taken on July 17, 1888, this image records a woodland planting of Jekyll's 'Munstead White' foxgloves and ferns. Photographs 41 and 42 were taken on the same day and provide an early record of the progress of the garden at Munstead Wood.

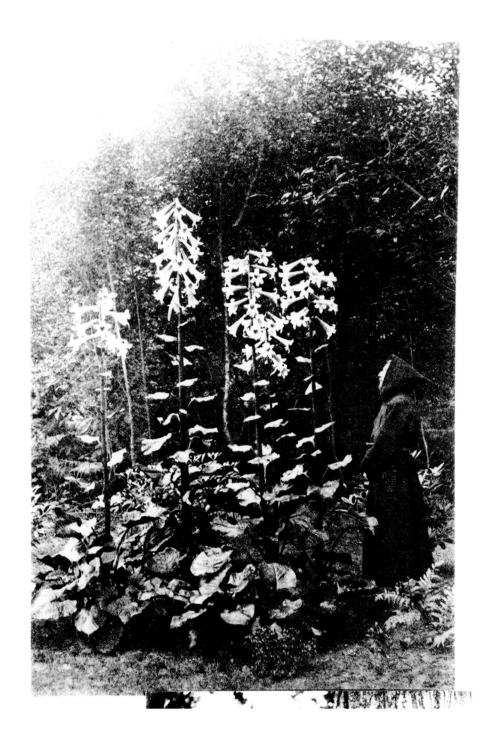

43. "HABIT BORROWED FROM A SUSSEX MONASTERY ON MY GARDENER, P. BROWN" · This early photograph is one of a series taken of a stand of *Cardiocrinum giganteum* in a woodland setting, probably near Munstead House. A similar photograph, but without the gardener, appeared as early as 1888 in *The Garden* magazine and is one of Jekyll's earliest published photographs.

BEGINNINGS

In addition to horticulture and garden design,
Jekyll was an accomplished landscape painter, embroiderer,
metalworker, and woodworker. Although she curtailed a number of
these interests in later years, the design sensitivity and
craftsmanship that she demonstrated were
applied in her landscape work.

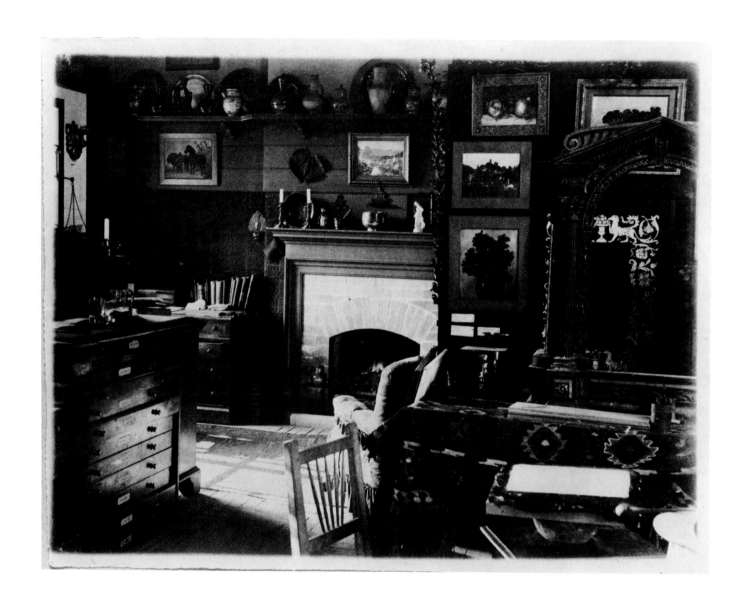

44. ''WORKSHOP—MUNSTEAD'' • An early photograph dating from 1885 or 1886 shows the interior of the workshop that Jekyll had at Munstead House, where she lived and worked prior to building her own house at Munstead Wood. At left can be seen flat files for craft supplies and samples for interior decorating work. The walls are lined with Jekyll's paintings and the upper shelf displays her pottery collection, acquired from her extensive travels. At the right center there is an example of her wood-inlay work.

45. (UNCAPTIONED) · A decorative box, which Jekyll photographed in 1885, shows some of her early design work; similar flat floral motifs appear in the embroidery and wood-carving projects.

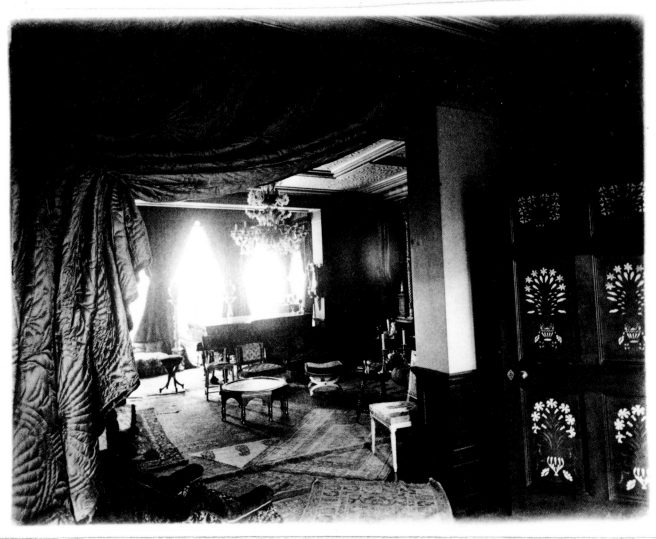

46. "LARGE QUILTED CURTAIN DESIGNED AND PARTLY WORKED BY G.J." · An interior design commission located at 43 Hyde Park Gate, London, was recorded by Jekyll in 1885 or 1886. In addition to the quilted curtain and the wall stencils, Jekyll designed and probably executed the wood-inlay door shown at the right.

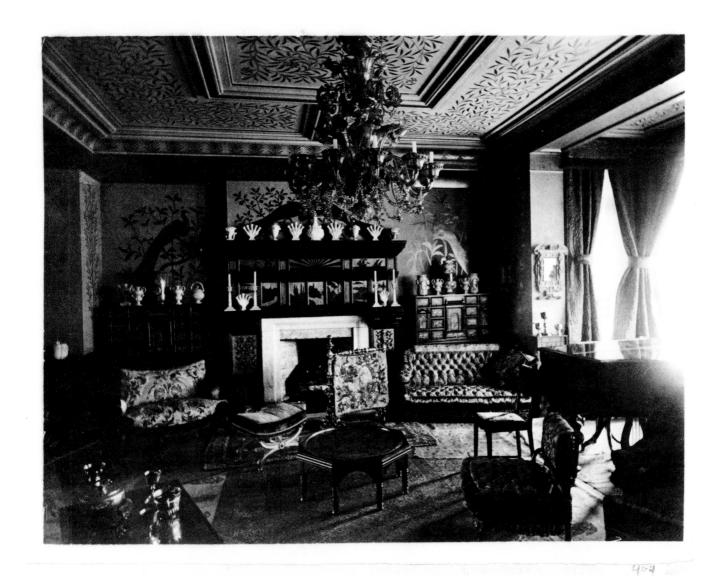

47. ''PEACOCK AND ORANGE TREES ON WALL BY G.J.'' · The clients were Jacques and Leonie Blumenthal,
who were part of Jekyll's group of musical and artistic friends that included the landscape painter
Hercules Brabazon, with whom Jekyll had studied.

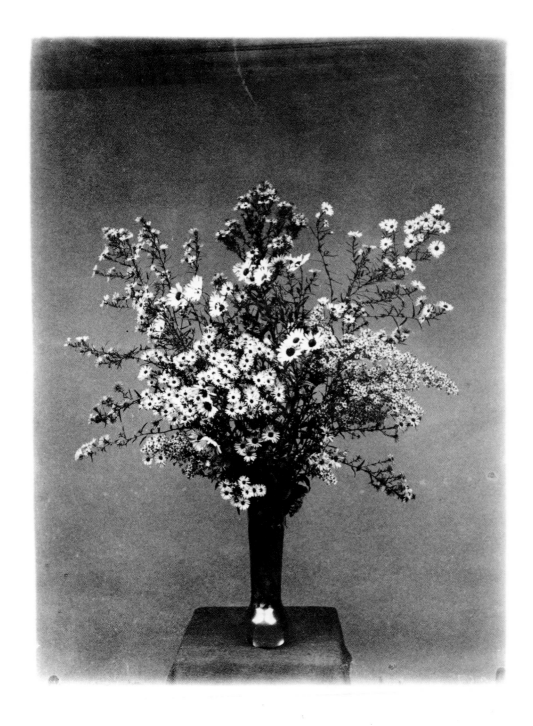

Three design principles regarding plant combinations which Jekyll used in her gardens can be seen in these indoor table arrangements: the blending of similar flower forms; the juxtapositioning of extreme textural contrast; and the repetition of a single flower type. Jekyll published a book about these studies entitled Flower Decoration in the House *in 1907.*

48. (UNCAPTIONED) • A simple arrangement of Michaelmas daisies was recorded in 1885 or 1886.

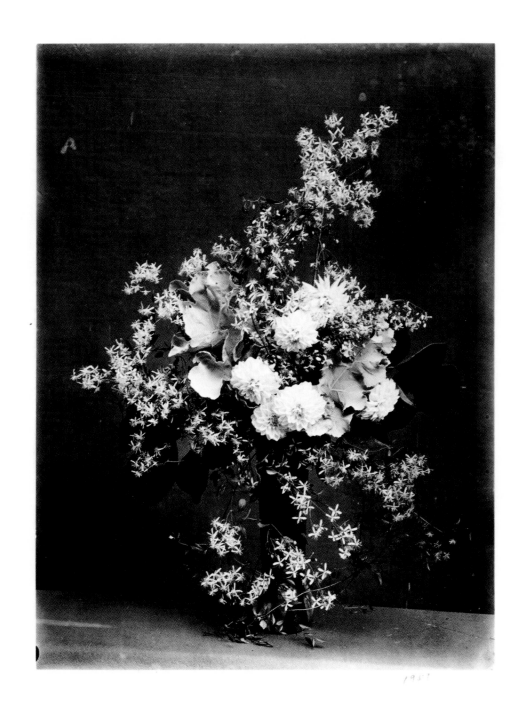

49. "WHITE DALHIA AND CLEMATIS FLAMMULA WITH SEAKALE AND MAGNOLIA LEAVES IN A TALL
MUNSTEAD GLASS" · Unable to find proper vessels for her arrangements, Jekyll designed glass containers,
one of which can be seen in this photograph from 1906.

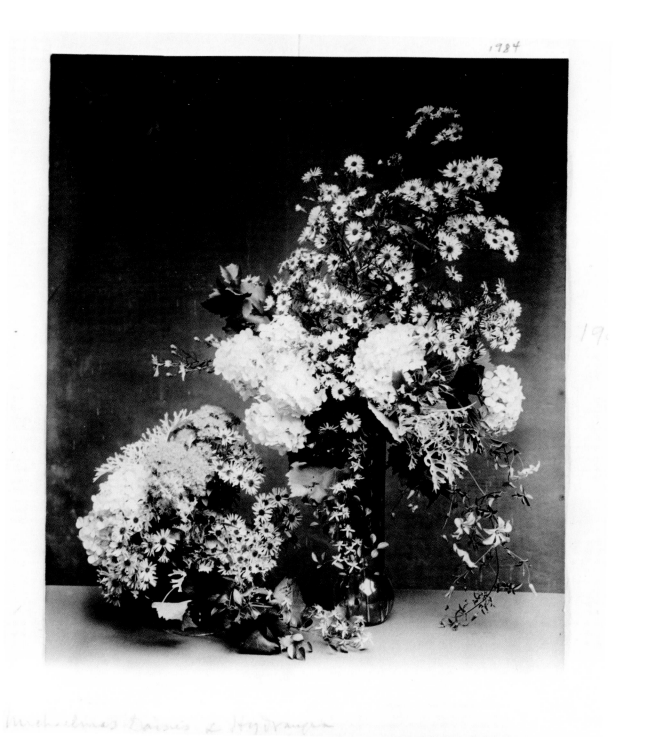

Michaelmas Daisies & Hydrangea

50. "MICHAELMAS DAISIES AND HYDRANGEA. OCTOBER 5, 1906." • The arrangement of asters and hydrangeas that Jekyll created was photographed at the same time as Photograph 23, "Aster Border Looking NW."

51. "MUNSTEAD BASKET" · Gertrude Jekyll designed this flower basket and had it made locally by F. Cobbett, 92A High
Street, Guildford. It was available in several sizes and advertised for sale in *The Garden* magazine in 1901,
the year Jekyll was editor of the magazine.

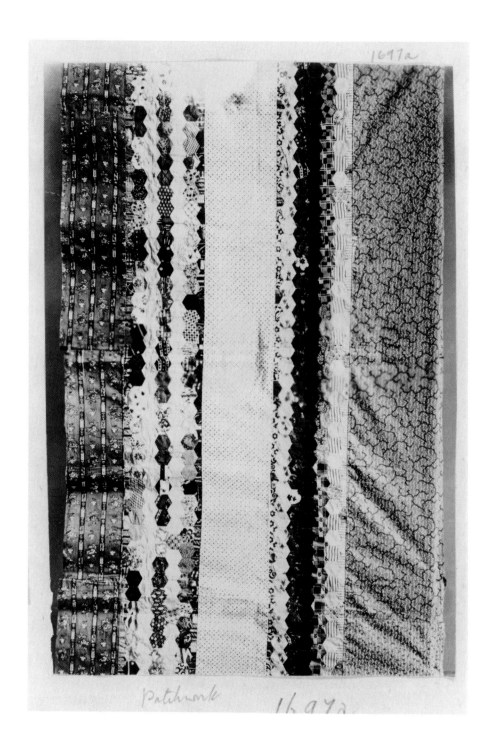

52. "PART OF A PATCHWORK QUILT—EARLY NINETEENTH CENTURY" · Jekyll collected many old-time rural
crafts, and her photographs of some of these collections became the subject of her book *Old West Surrey*, published in 1904.
Her fascination with pattern can be seen in her patchwork and clothing collections.

PHOTOGRAPHIC STUDIES

Jekyll took up photography in 1885, and as early as July of that year one
of her botanical images appeared as an engraving in *The Garden* magazine. During
the next few years engravings of several of Jekyll's photographs continued to appear in
the magazine and later in Robinson's popular book, *The English Flower Garden*.
Jekyll made numerous annotations in her photo-notebooks detailing what
books her photographs appeared in. In addition to using the camera
to record plant species, Jekyll also photographed garden
architecture and other built elements. The following
group of images dates from 1885–86 and
most are previously unpublished.

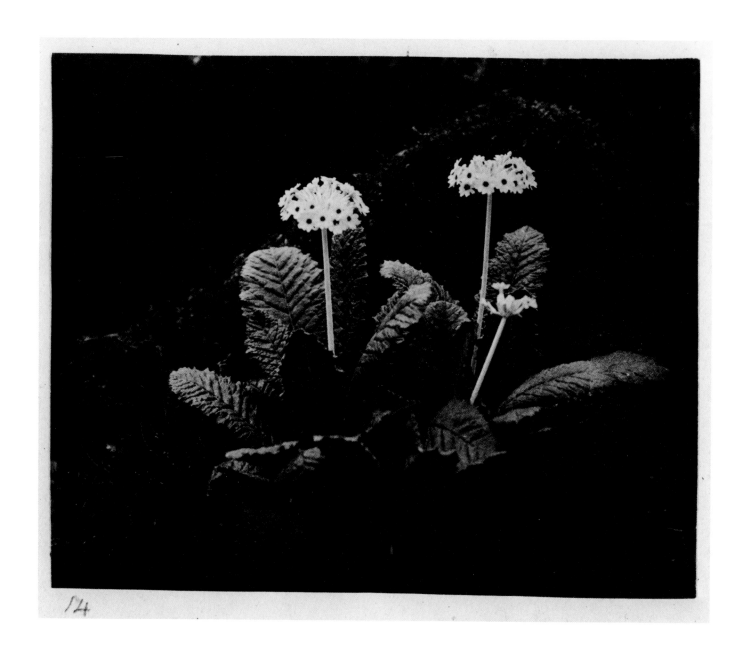

53. (UNCAPTIONED) · This unpublished close-up study of a primrose appeared within
the first few pages of Jekyll's photo-notebooks.

54. "GARDEN GATE AND AGAPANTHUS—EASTBURY" • Tubs of *Agapanthus umbellatus* appeared in numerous garden schemes, including one as late as 1924 for Lutyens' Queen Mary's Dolls' House.

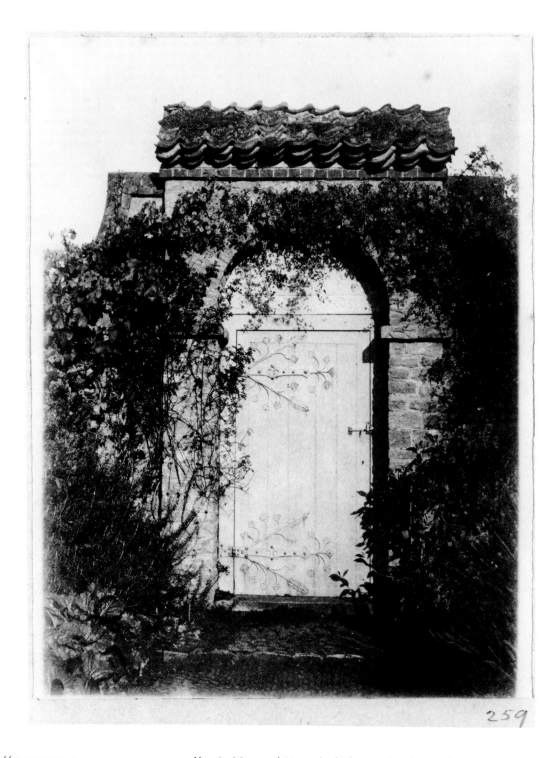

259

55. "GARDEN DOOR — MUNSTEAD" · At Munstead House both the wooden door and the doorway wreathed in *Clematis graveolens* anticipate the south door at Munstead Wood in the 1890's.

288

56. "VILLAGE FOUNTAIN HASCOMBE" · The simple architecture of a stone fountain shows some
of the local building traditions that appealed to Jekyll.

57. "SHED ROOF. THATCHED WITH HOOP-CHIP" • Jekyll's Potting Shed at Munstead Wood shows her interest in the use of local materials. A thatched roof has been created out of hoop-chip, a by-product of a rural barrel-hoop industry.

58. "WHITE ROSE ON OLD COTTAGE PORCH IN BUSBRIDGE" · The use of climbing roses, such as *Rosa alba* recorded in a local cottage garden in 1886, was extended to Jekyll's own cottage garden at The Hut as well as her numerous summer borders near the Quadrangle.

59. "STILE AND GATE HASCOMBE ROAD" · Jekyll describes the simplicity and elegance of a five-barred gate in *Old West Surrey,* for which this photograph was used.

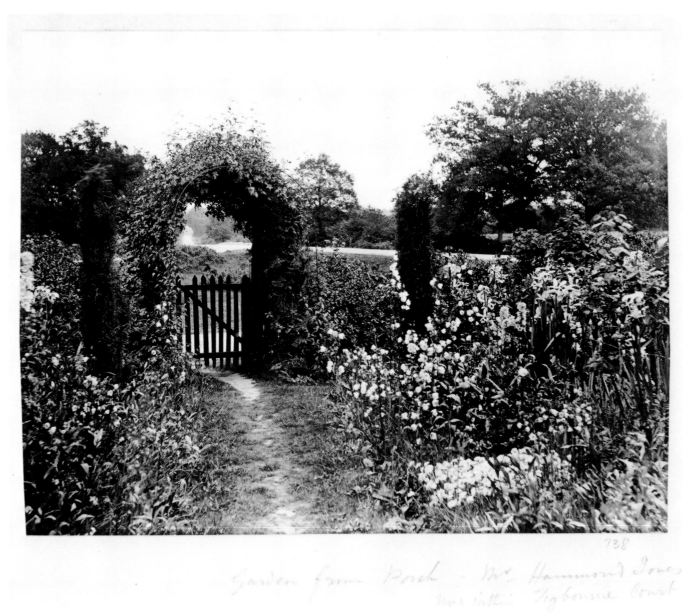

60. "GARDEN FROM PORCH — MR. HAMMOND JONES. NOW WITHIN TIGBOURNE COURT" · Jekyll captured this cottage garden in 1887, prior to Lutyens' scheme of 1899 for a house and garden at Tigbourne Court which incorporated the property.

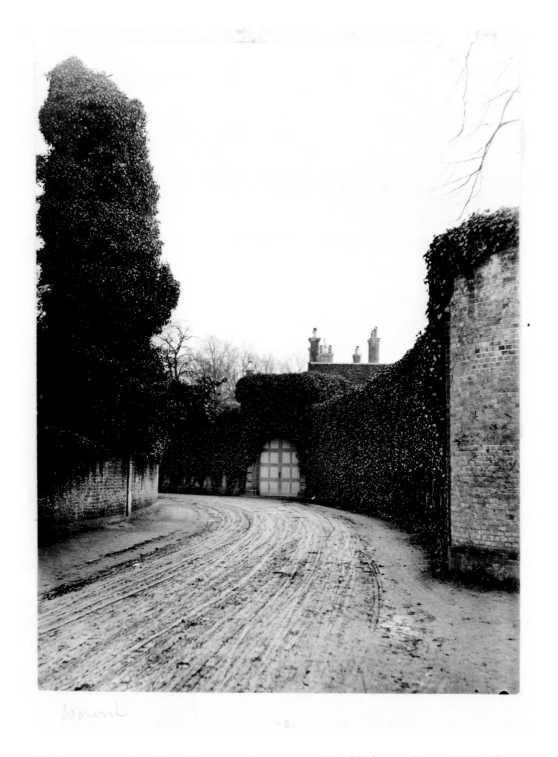

61. "WONERSH" · Dense foliage covering a stone wall could often produce a pleasing effect.

62. "WEIGELA MILFORD HOUSE" · Another photograph of a local wall and garden door shows
the natural tangle of bare vines as a design inspiration.

Enton Mill

Jekyll was fascinated with the rural landscape of Surrey and its vernacular architecture, and with Lutyens shared an especial interest in local building methods and traditions. In 1904 Jekyll published her study of rural life entitled Old West Surrey, *and used some of the following photographs from her large collection on this subject.*

63. ''ENTON MILL'' · Well-worn steps at the back of an ancient flour mill are one component of a vernacular building that has been constructed without pretense from available materials.

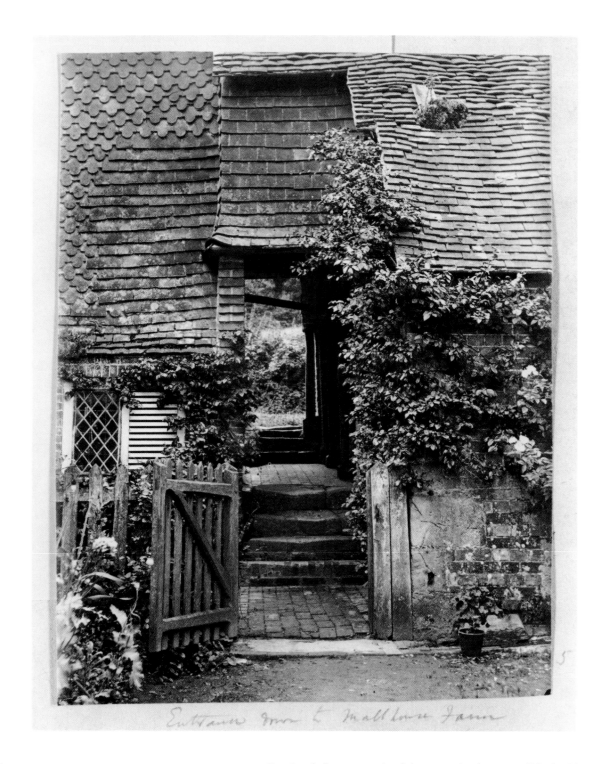

Entrance down to Malt house Farm

64. "ENTRANCE DOWN TO MALT HOUSE FARM" · Level changes at a local farm are simply accomplished with two sets of stone steps separated with pavers, the texture of which is echoed in the line of the tile roofs and softened with the vine.

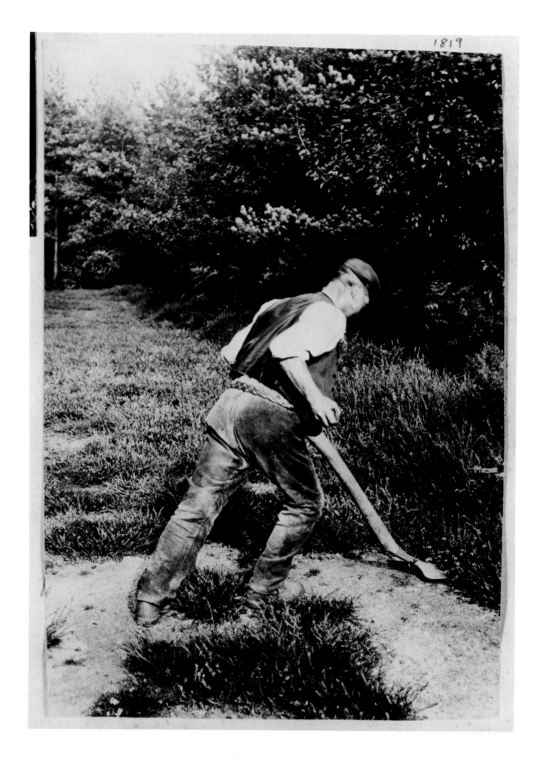

65. "CUTTING HEATH-TURF" · Local tools, such as this spade for cutting heath-turf for
burning or heath-sod for cottagers' fuel, were put to use at Munstead.

66. "HEATH-TURF CUTTING TOOL AT DOOR OF MUSHROOM HOUSE" · Jekyll's Mushroom House at Munstead, which she admitted that she never used for mushroom-growing, provides a rustic background for her photograph of the special spade.

67. "GOURDS. ALBERT AND DAVID BORALL. 11 OCTOBER 1906" · Jekyll posed father and son and
their produce against the mature fig vine in front of the loft building.

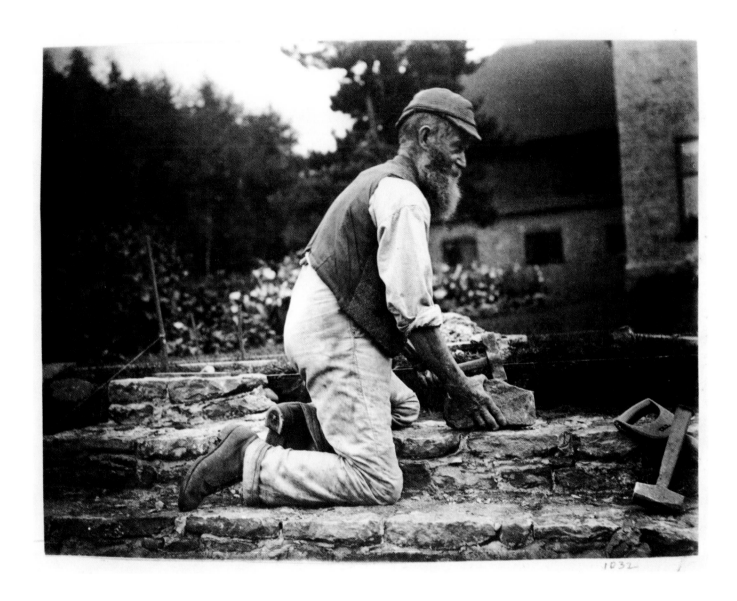

68. "THE OLD BRICKLAYER" · In this local bricklayer, who may be at work at Munstead Wood, Jekyll recorded someone "nearly stone deaf [and] left-handed" whose work represented perfect knowledge of local ways.

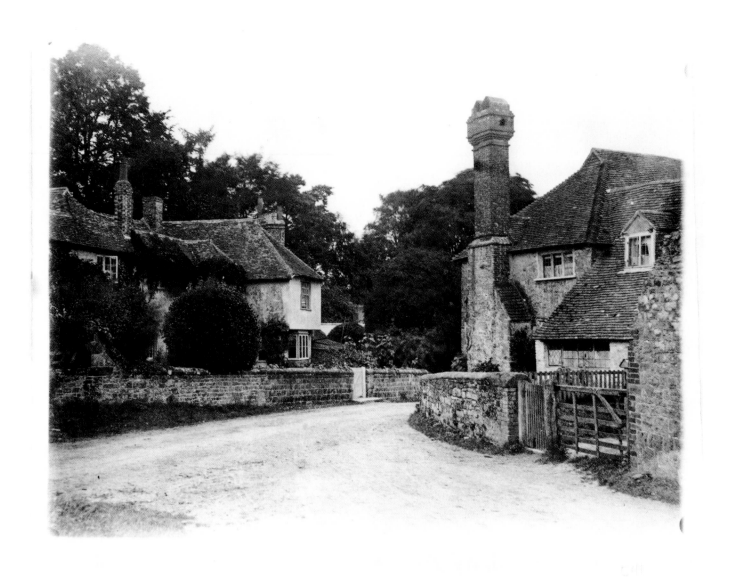

69. "OLD COTTAGES" · An unpublished photograph from 1886 captures picturesque Fittleworth,
a village which features local examples of stonework and building design.

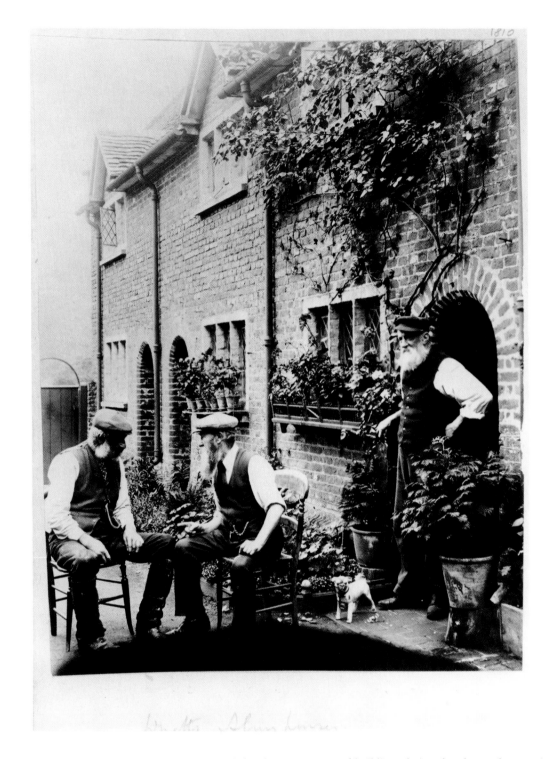

70. "WYATT'S ALMSHOUSES" · Architectural detailing in a group of buildings designed to house the poor in the early seventeenth century provides a backdrop for an overposed grouping of men in Farncombe.

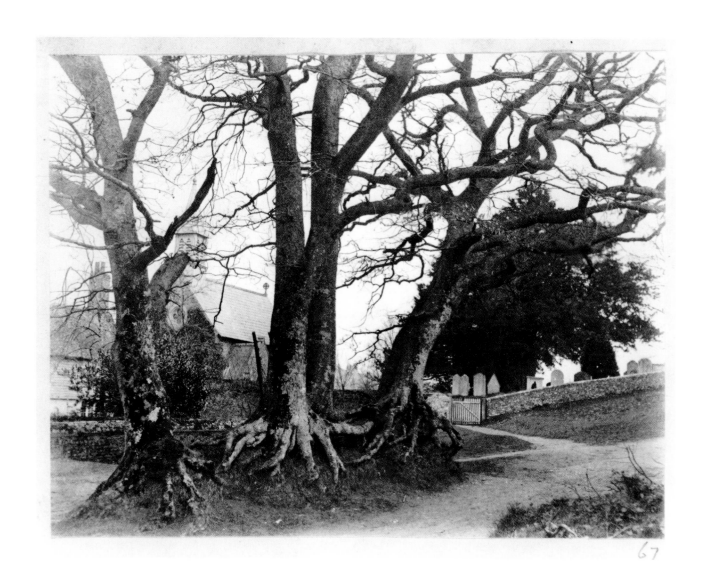

71. (UNCAPTIONED) · An early photograph taken in 1885 records an unidentified village churchyard, which is the background for a struggling group of trees with picturesquely intertwined roots.

In addition to designed land-scapes, Jekyll documented trees throughout her photographic career. These photographs range in date from 1885 through 1914. Jekyll states, "Within half a mile of my home is a deep hollow lane. . . . In Summer it is shaded by the wide-spreading branches of the trees, mostly Beeches, that grow above." Her interest in tree roots was partly an exploration of their structure, but their tangled forms created by a will to survive also provided dra-matic photographic subjects.

72. ''BEECH UNSTEAD LANE'' • In 1900 Jekyll wrote, "For the Beech always
seems to me to be the true aristocrat among trees."

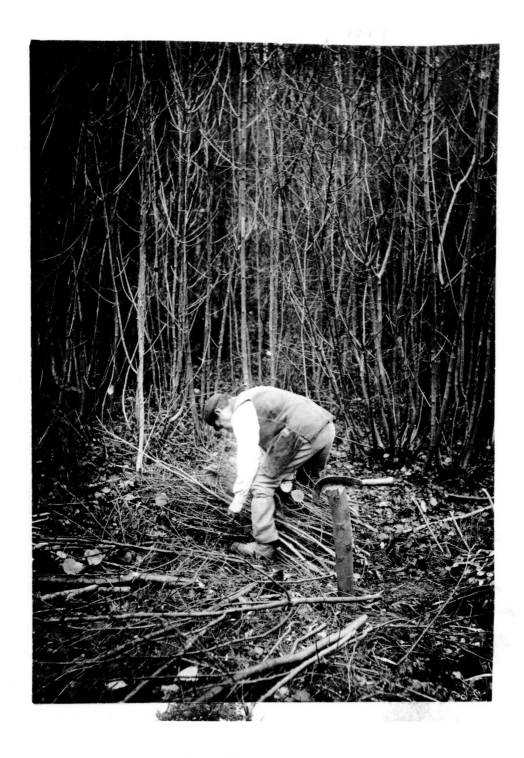

73. "COPSE-CUTTER FAGGOTING UP" • Jekyll has recorded the process of the solitary winter activity of cutting and bundling up twigs for use both as fuel and as a component of the neighborhood hoop-making industry.

74. "WILLOWS GREAT TANGLEY" · An unpublished image of 1887 shows the gnarled forms of pollarded trees on the property of Great Tangley Manor, an Elizabethan manor house in a nearby village.

75. "OAK ROOTS" · Intricate forms of tree roots are exposed at the top of a steep embankment
that is typical of the deep country lanes near Munstead.

PORTRAITS

Portraiture was also among Jekyll's photographic interests.

Many were images of family and friends, and all

but the first image were included in her

popular book *Children and Gardens*,

which she published in 1908.

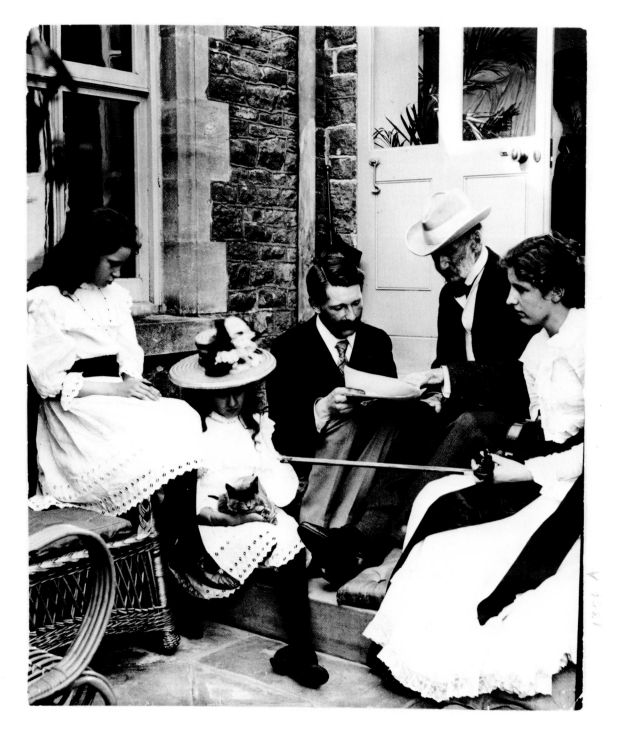

76. "H. B. BRABAZON, LEONARD BORWICK, DOLLY MUIR MACKENZIE (MRS. MARK HAMBURG), WITH KITTEN, BARBARA JEKYLL (MRS. BERNARD FREYBERG), PAMELA JEKYLL (MRS. REGINALD MCKENNA). PHOTOGRAPHED BY G. JEKYLL AUGUST 6, 1899" · The inclusion of married names shows that Jekyll worked on labeling her photo-notebooks in the last years of her life. The landscape painter Brabazon, the musician Leonard Borwick, and Dolly Muir MacKenzie were all family friends; Barbara and Pamela Jekyll were the daughters of her brother Herbert Jekyll, who lived nearby at Munstead House.

77. "PAMELA IN BASKET" · Pamela Jekyll (1889–1943), Herbert Jekyll's younger daughter, posed for numerous photographs while visiting Munstead Wood. The large weeding basket contrasts with the detailing of the stonework terrace.

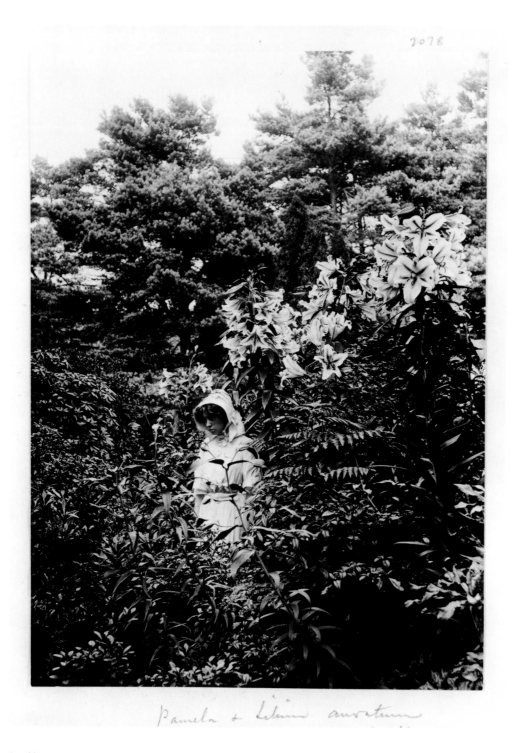

Pamela & Lilium auratum

78. "PAMELA AND LILIUM AURATUM — MUNSTEAD HOUSE" · About seven years later, Pamela poses dutifully among the giant lilies at Munstead House.

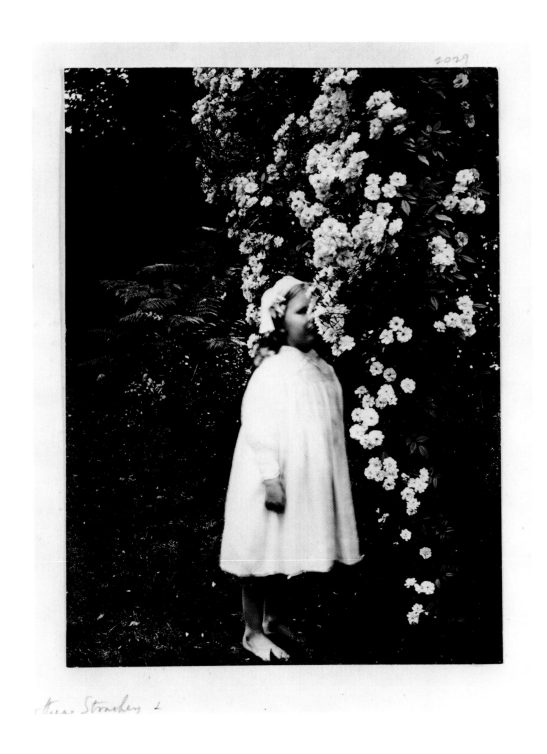

79. ''DOROTHEA STRACHEY — ROSE MCFARLAND'' • Cascading roses highlight a fragrant corner of the garden.

80. ''TABBY'' · Jekyll writes in *Home and Garden*, "When Tabby and I are walking near either of the gates he runs on and mounts one of the posts, and we play the game of Gate-post."

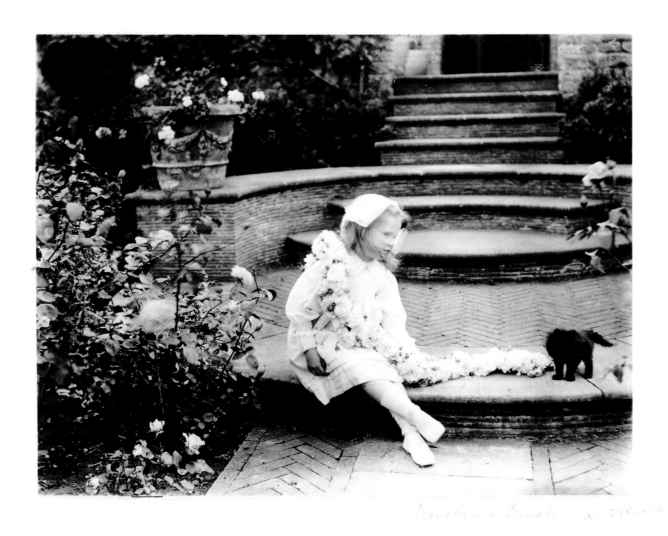

81. "DOROTHEA AND DINAH AT ORCHARDS" · Dorothea Strachey is pictured in the Dutch Garden at Orchards (1897–99), one of the more important Lutyens and Jekyll design collaborations, built just after Munstead Wood and located down the road from it.

82. "JEAN AND ANN GIBSON" · The barefoot twins learn to knit.

Shoes & Stockings

83. ''SHOES AND STOCKINGS'' • A rustic garden seat, created with encrusted tree stumps, and tucked in among ferns and other foliage at woods' edge, provided the proper place for highly polished indoor shoes and cumbersome stockings.

A NOTE ABOUT
THE PHOTOGRAPHS

The preceding photographs are a selection from the exhibition entitled "Gertrude Jekyll: A Vision of Garden and Wood," sponsored by Bank of Boston. They have been reproduced directly from Gertrude Jekyll's personal photo-notebooks in the Documents Collection, University of California, Berkeley. They represent a variety of subjects that includes rural and vernacular essays as well as garden compositions. Although a number of these images will seem familiar to those who have studied Jekyll's books, they merit an inquisitive inspection. The newly made prints, from which these images were prepared, reflect modern reproduction techniques and have brought to light more detail than ever appeared in the poor-quality reproductions that were published in Jekyll's lifetime in magazines or books. Many photographs have never been published before and augment the range of Jekyll's interests. The unpublished images generally fall into two categories: those that were alternate and subsequently rejected views for a projected publication and those of a more personal nature that were never intended for publication.

Although most of the photographs are excellent visual documents, a few of Jekyll's early images of poor quality as well as later ones that are decidedly out of focus have been included. Since the photographs come from personal albums with prints in some cases layered one on top of another, rather than from professional photograph files, it was thought that they should be reproduced as they appeared in the albums, without cropping. Whenever possible Jekyll's own titles for her photographs have been included in the captions that accompany the photographs. These titles represent either her penciled notation in a photo-notebook or a caption that she wrote for the publication of a photograph in a book. Jekyll's original titles sometimes refer to outdated botanical nomenclature, such as Megasea (bergenia) or Funkia (hosta), and no attempt has been made to update this in the captions.

The dating of the photographs has been a challenging matter, since fewer than two dozen actually have dates penciled in by Gertrude Jekyll directly on the titles or on the backs of the photographs themselves. Working with these dated images, and taking into consideration the first publication date in one of Jekyll's books or articles, it has been possible to draw studied conclusions. Further information regarding dating and publication references for each photograph can be found in "Caption Notes and Sources" on page 139.

BIBLIOGRAPHY

Judith B. Tankard

I

BOOKS BY GERTRUDE JEKYLL,
LISTED IN ORDER OF PUBLICATION

Wood and Garden: Notes and Thoughts, Practical and Critical, of a Working Amateur, by Gertrude Jekyll. With Illustrations from Photographs by the Author. London: Longmans, Green and Co., 1899. 286 pages. 66 illustrations.

Jekyll's first book consists in part of a series of articles entitled "Notes from Garden and Woodland" that appeared in 1896 and 1897 in *The Guardian*. Most of the photographs were taken at Munstead Wood, and some of them had already appeared as engravings in William Robinson's book *The English Flower Garden*, as well as his journals *The Garden* and *Gardening Illustrated*. This popular book went through many printings and editions.

Mrs. E.V Earle: "February 23rd [1899]. . . . A treat has come for all of us amateur gardeners this month in the publication of a long-looked-for gardening book by Miss Jekyll, charmingly illustrated from photographs of her own. But good as are these reproductions, in my opinion they can never compare with woodcuts or steel engravings, and they give but a faint idea of the unusual charm and beauty of her self-created garden." (*More Pot-Pourri From a Surrey Garden* [London: Smith, Elder & Co., 1899], pp. 211–12).

Home and Garden: Notes and Thoughts, Practical and Critical, of a Worker in Both, by Gertrude Jekyll. With 53 Illustrations from Photographs by the Author. London: Longmans, Green and Co., 1900. 301 pages.

A range of topics, some of which would later be expanded into longer studies, is fully illustrated with photographs of vernacular and rural scenes as well as garden views of Munstead Wood.

Lilies for English Gardens: A Guide for Amateurs, Compiled from Information Published Lately in "The Garden," With the Addition of Some Original Chapters, by Gertrude Jekyll. London: Country Life, 1901. 72 pages. 58 illustrations from photographs and drawings.

This is the first of Jekyll's books to be published in The Country Life Library series, which was co-published by Charles Scribner's Sons, New York, for American audiences. It is a short specialized book illustrated with photographs by Ellen Willmott and G.F. Wilson as well as by the author.

Wall and Water Gardens, by Gertrude Jekyll. London: Country Life, [1901]. 177 pages. 132 illustrations from photographs.

Most of the photographs represented are by Jekyll; both *Country Life* and *The Garden* are credited. Also acknowledged are James Hudson, who compiled the list of water lilies, and Henry Correvon, a frequent correspondent in *The Garden*, as well as William Robinson. One of Jekyll's more popular books, this title had eight editions, each one of which had modifications to the text or illustrations. By the sixth edition in 1920, five new chapters had been added, including two on heath gardens. The final edition was revised by Jekyll in 1932 and was entitled *Wall, Water, and Woodland Gardens* to incorporate the addition of new chapters on woodland gardens and Asiatic primulas.

See book review, probably by E.T. Cook, in *The Garden* (6 July 1901, pp. 11–12).

Roses for English Gardens, by Gertrude Jekyll and Edward Mawley. London: Country Life, 1902. 166 pages. 189 illustrations from photographs.

Of the twenty-three chapters in this book, the first sixteen are by Jekyll and are entitled "Old and New Garden Roses and Their Beautiful Use in Gardens," and the remaining seven chapters by Mawley detail the practical aspects of rose-growing. The illustrations include photographs by Ellen Willmott as well as by Jekyll.

Old West Surrey: Some Notes and Memories, by Gertrude Jekyll. London: Longmans, Green and Co., 1904. With 330 Illustrations from Photographs by the Author. 320 pages.

This is Jekyll's largest published collection of non-gardening photographs detailing her interest in vernacular and rural arts. Although the book was not reprinted, it was later substantially rewritten as *Old English Household Life* in 1925, which see.

Some English Gardens. After Drawings by George S. Elgood, R.I., with Notes by Gertrude Jekyll. London: Longmans, Green and Co., 1904. 130 pages. 50 illustrations from watercolors by Elgood.

A folio-sized book consisting of descriptions by Jekyll of historic gardens and garden elements in Scotland as well as England was sumptuously illustrated by the well-known English watercolorist, George Elgood. After its initial publication in October 1904, it was reprinted several times; a new edition was issued in December 1905 and was printed until March 1920.

Flower Decoration in the House, by Gertrude Jekyll. London: Country Life, 1907. 98 pages. 58 illustrations from photographs. 6 line drawings.

This was another specialized book that probably did not have any further editions. The photographs were all taken by Jekyll.

Colour in the Flower Garden, by Gertrude Jekyll. London: Country Life, 1908. 148 pages. 85 illustrations from photographs. 10 plans and 5 fold-out plans.

Probably Jekyll's most influential book, this one was entirely illustrated by Jekyll with both plans and photographs. In later editions, of which there were many, the book was entitled *Colour Schemes for the Flower Garden*. Each subsequent edition had modifications to both the text and the illustrations. Later editions have a tipped-in color frontispiece.

Children and Gardens, by Gertrude Jekyll. With 106 Illustrations by the Author. London: Country Life, 1908. 110 pages.

A second edition of this book was published in 1934, with an Introduction by *Country Life* writer Bernard Darwin. The new edition retained all of Jekyll's line drawings and some of her photographs, but "reinforced" it with new photographs taken by Eric Hosking.

Gardens for Small Country Houses, by Gertrude Jekyll and Lawrence Weaver. London: Country Life, [1912]. 260 pages. Tipped-in color frontispiece by author. 387 text illustrations from photographs and plans.

This quarto-sized book went through many editions: second (1913), third (1914), fourth (1920), fifth (1924), sixth (1927). The text remained the same, but the Introduction was frequently rewritten. It appears to have been designed as a companion volume to Lawrence Weaver's *Small Country Houses of To-Day* [1912], *The House and Its Equipment* [1912], and *Small Country Houses: Their Repair and Enlargement* (1914), all published by Country Life.

A book review by Arthur T. Bolton appeared in *Country Life* (Vol. 32, 7 December 1912, pp. 827–30).

Annuals and Biennials: The Best Annual and Biennial Plants and Their Uses in the Garden, by Gertrude Jekyll. With Cultural Notes by E.H. Jenkins. London: Country Life, Ltd., [1916]. 174 pages. 41 illustrations from photographs, 2 tipped-in color plates, 1 fold-out plan.

Another specialized book, with a chapter contributed by E.H. Jenkins, the author of several gardening books for Country Life.

Garden Ornament, by Gertrude Jekyll. London: Country Life, 1918. 460 pages. Tipped-in color illustration by George Elgood, R.I.

A large folio-sized book with little text is illustrated with stock photographs from Country Life and a few line drawings by Jekyll. A new edition, published in 1927, was written by Jekyll and Christopher Hussey. Although the format and most of the plates were the same, the text and most of the captions were completely rewritten.

Old English Household Life: Some Account of Cottage Objects and Country Folk, by Gertrude Jekyll. London: B.T. Batsford, 1925. 222 pages. 177 illustrations from photographs.

Although a number of the illustrations appeared in *Old West Surrey*, this is essentially a different book, with many additional illustrations from other sources. A new edition, published in 1939, was written by Jekyll and Sydney R. Jones. Few of the original photographs were retained, and the text was substantially rewritten.

II

CHAPTERS BY GERTRUDE JEKYLL IN BOOKS,
LISTED IN ORDER OF PUBLICATION

This listing represents a selection of signed prefaces, short pieces, or chapters that were included in books or anthologies by other authors. Jekyll had a long-standing relationship with Country Life and its proprietor, Edward Hudson, who visited Munstead Wood in 1900 with his garden editor, E.T. Cook. After that date Jekyll's book design work, with design motifs similar to those that appear on all her octavo-sized books, can be seen in a number of Country Life editions, such as in the Small Country Houses of To-Day series. With one or two exceptions, these designs were unacknowledged. In addition to unsigned pieces in *Country Life* magazine, she may have written unsigned material for a number of Country Life books, such as *The Century Book of Gardening: A Comprehensive Work for Every Lover of the Garden*, edited by E.T. Cook [1900]. The three-volume Country Life publication entitled *Gardens Old and New* (c. 1901–1908), a compendium based on signed and unsigned articles by various authors that appeared in *Country Life* magazine, includes two unsigned articles by Jekyll: "Orchards, Surrey" in Volume Two and "St. Catherine's Court, Somerset" in Volume Three. These two volumes include a line drawing on the title page signed "G.J." Interestingly enough, Volume One contains an earlier piece on St. Catherine's Court, probably written by Country Life photographer Charles Latham.

"Colour in the Flower Garden," by G.J., in *The English Flower Garden: Style, Position, & Arrangement*, by W[illiam] Robinson, F.L.S. First Edition. London: John Murray, 1883.

Jekyll's article consistently appeared in all editions of this popular book up to the thirteenth edition (1921).

"Preface," by Gertrude Jekyll, in *Gardening for Beginners: A Handbook to the Garden*, by E.T. Cook. London: Country Life, 1901, pp. v–vi.

E.T. Cook was a prolific author who was also garden editor of *Country Life*, and Jekyll and Cook were co-editors of *The Garden* in 1900–01.

"On Garden Design Generally," by Gertrude Jekyll, in *The House and Its Equipment*, edited by Lawrence Weaver. London: Country Life, [1912], pp. 134–37.

"Preface," by Gertrude Jekyll, in *The Well-Considered Garden*, by Mrs. Francis King. New York: Charles Scribner's Sons, 1915, pp. 9–10.

"Preface," by Gertrude Jekyll, in *The Charm of English Gardens*, by Wilhelm Miller. London: Hodder and Stoughton, [n.d.], [4 pp.]

"Garden Planning," "The Water Garden," and other articles by G. J., in *Black's Gardening Dictionary*, edited by E.T. Ellis. London: A. & C. Black Ltd., 1921.

"The Garden," by Gertrude Jekyll, in *The Book of the Queen's Dolls' House*, edited by A.C. Benson and Sir Lawrence Weaver. London: Methuen & Co. Ltd., 1924, pp. 151–55.

"Foreword," by Gertrude Jekyll, V.H.M., in *The Flower Garden Day by Day*, by Mrs. Francis King. New York: Frederick A. Stokes Company, 1927, p.ix.

"Introduction," by Gertrude Jekyll, in *Colour Planning of the Garden*, by G.F. Tinley, et al. London: T.C. and E.C. Jack Ltd., 1929, pp. ix–xviii.

III

MAGAZINE ARTICLES BY GERTRUDE JEKYLL

Gertrude Jekyll wrote approximately 1,000 signed magazine articles that appeared in a variety of publications. She regularly wrote for *The Garden* (1881–1927), *Gardening Illustrated* (1881–1932), and *Country Life* magazine (1901–28), with much duplication of material among the three journals. A list of signed articles can be found in "Bibliography of Gertrude Jekyll's Published Works," by

Margaret Hastings and Michael Tooley, in *Gertrude Jekyll: Artist, Gardener, Craftswoman*, edited by Michael Tooley (Witton-Le-Wear: Michaelmas Books, 1984, pp. 137–51). An anthology of some of her writings can be found in *A Gardener's Testament: A Selection of Articles and Notes by Gertrude Jekyll*, edited by Francis Jekyll and G.C. Taylor (London: Country Life, Ltd., 1937).

The following listing, alphabetical by title, represents a small selection of articles on her garden or borders at Munstead Wood that were illustrated with photographs of Jekyll's garden.

"Border Flowers and Their Colour Harmonies," *The Garden*, Vol. 85 (21 May 1921), pp. 252–53.

"A Border of Lupine and Iris," *The Garden*, Vol. 80 (14 October 1916), p. 503.

"Clematis Montana and Its Many Uses," *The Garden*, Vol. 83 (22 February 1919), p. 80.

"Garden Notes" [Lent Hellebores and The Nut Walk], *Country Life*, Vol. 53 (10 March 1923), p. 326.

"The Grey Border for Late Summer," *Country Life*, Vol. 52 (1922), pp. 776–77.

"In the Garden: An April Garden," *Country Life*, Vol. 31 (27 April 1912), pp. 611–12.

"In the Garden: The Hardy Flower Border," *Country Life*, Vol. 31 (6 April 1912), pp. 514–15.

"A July Flower Border," *The Garden*, Vol. 80 (11 November 1916), p. 548.

"Lenten Roses," *The Garden*, Vol. 87 (17 March 1923), p. 136.

"Munstead Bunch Primroses," *The Garden*, Vol. 82 (22 June 1918), p. 242.

"Munstead Bunch Primroses," *The Garden*, Vol. 87 (26 May 1923), pp. 256–57.

"The Nut Walk," *The Garden*, Vol. 83 (8 February 1919), p. 52.

"A Primrose Garden," *Country Life*, Vol. 53 (28 April 1923), pp. 568–69.

"Scotch Briars in House and Garden Landscape," *The Garden*, Vol. 61 (13 July 1901), p. 30.

"Spring Flowers in a Surrey Garden," *The Garden*, Vol. 83 (3 May 1919), pp. 204–05.

PHOTOGRAPHS BY GERTRUDE JEKYLL
PUBLISHED IN BOOKS AND ARTICLES

Jekyll often supplied her photographs in unsigned magazine articles and in books and articles by other authors, and these were often not acknowledged. Her books *Wood and Garden*, *Home and Garden*, *Wall and Water Gardens*, *Old West Surrey*, *Colour in the Flower Garden*, and *Children and Gardens* were illustrated entirely by her own photographs, whereas her remaining books included photographs from other sources.

Shortly after learning the art of photography in 1885, her first photographs began to appear in *The Garden* magazine; the engravings were done by A. Kohl. The following is a listing of Jekyll's earliest published photographs, in order of publication.

"Flower-Spray of Carpenteria Californica. . . from a photograph taken at Munstead in June," by G.J., West Surrey, *The Garden*, Vol. 28 (18 July 1885), p. 64.

"A Study of Romneya Coulteri Flowers. Engraved for 'The Garden' from a Photograph," by G.J., *The Garden*, Vol. 29 (6 March 1886), p. 207.

"A Border of Michaelmas Daisies" ("engraved for 'The Garden' from photographs taken at Munstead last autumn. W[illiam] R[obinson]"), *The Garden*, Vol. 29 (20 March 1886), pp. 252–53.

"Group of tall Mulleins in Heath near Scotch Firs, but not shaded by them. Flowers, yellow; spikes, 6 to 9 feet high. Engraved for 'The Garden' from a photograph taken at Munstead, August 11, 1885," *The Garden*, Vol. 29 (3 April 1886), p. 297.

In addition to writing an essay in William Robinson's *The English Flower Garden*, Jekyll contributed photographs for the illustrations, beginning with the second edition (1889), in which at least two of her photographs appear, including "Climbing Rose (Rosa Alba) on Cottage Porch, Surrey" and "A Border of Michaelmas Daisies in a Surrey Garden." The third edition (1893) has about a dozen identifiable illustrations, including one entitled "Newly-Formed Pergola at Munstead," which was designed and built in 1893. Although the illustrations come from many sources in the

book, almost all previously published in *The Garden* magazine, there are many that were probably supplied by Jekyll, who may have treated the book as a photo assignment.

Although Jekyll is sometimes acknowledged as a contributor of editorial advice or photographs, the specific photographs are not credited. All photographs that were published by Country Life have the imprint of Hudson and Kearns, Printers. Photographs taken by Jekyll appear in the following books:

The Century Book of Gardening, edited by E.T. Cook. London: Country Life, c. 1900.

Gardening for Beginners, by E.T. Cook. London: Country Life, 1901.

Trees and Shrubs for English Gardens, by E.T. Cook. London: Country Life, 1902.

A History of Gardening in England, by The Hon. Alicia Amherst. Third Edition. New York: E.P. Dutton, 1910.

The Hardy Flower Book, by E.H. Jenkins. London: Country Life, 1913.

The Modern English Garden, by E.H.M. Cox. London: Country Life, c. 1913.

The Modern Garden, by G.C. Taylor. London: Country Life, Ltd. 1936.

V

MUNSTEAD WOOD IN GERTRUDE JEKYLL'S TIME
(1888–1932)

In addition to Jekyll's detailed descriptions in *Colour in the Flower Garden*, *Wood and Garden*, and *Home and Garden*, as well as magazine articles, some of the many visitors who came to Munstead Wood recorded their impressions of Jekyll and her garden in words or paintings. The following alphabetical listing is a selection of those books or impressions.

Allingham, Helen, and Marcus Huish, "A Garden in Surrey," *Happy England* (London: A.& C. Black, 1903).

Illustrated with 2 watercolors of "South Border 1900" and "South Border 1902" by Allingham, a famous watercolor artist who lived in Witley.

Baker, Herbert, *Architecture and Personalities* (London: Country Life, 1944), pp. 15–16.

"She was . . . not only an expert gardener, a planter of flowers, but she had the painter's sense for their arrangement in colour harmonies."

Brewster, Kate, "Gertrude Jekyll," *Home Acres*, Vol. 16, No. 4 (February 1929), p. 117.

"The famous primulas were coming into bloom. The nut walk was spangled with delicate leaves and the borders were rich black soil with arabesques of promising shoots breaking the surface."

[Cook, E.T.], "Munstead House and Its Mistress," *Country Life Illustrated*, Vol. 8 (8 December 1900), pp. 730–39.

Illustrated with 17 photographs.

[Cook, E.T.], "Munstead Wood, Godalming, The Residence of Miss Jekyll," *Gardens Old and New*, Vol. 2 (London: Country Life, c. 1907), pp. 39–44.

Earle, Mrs. C.W., *Pot-Pourri From a Surrey Garden* (London: Smith, Elder & Co., 1897), pp. 250–51.

Elgood, George, and Gertrude Jekyll, "Michaelmas Daisies," *Some English Gardens* (London: Longmans, Green and Co., 1904), pp. 121–24.

Illustrated with a watercolor of "Michaelmas Daisies, Munstead Wood" by George Elgood.

Falkner, Harold, in Betty Massingham, *Miss Jekyll: Portrait of a Great Gardener* (London: Country Life Limited, 1966), pp. 68–70.

The architect Harold Falkner, from Farnham, Surrey, was a frequent visitor to Munstead Wood from 1900 on and has left an eye-witness account of the gardens. "My introduction to Munstead Wood garden was a disappointment because (a) I did not then know enough about gardening to appreciate it, (b) I was not sufficiently an artist to understand restraint."

Gloag, M. R., "A Modern Garden, Surrey," *A Book of English Gardens* (New York: The Macmillan Company, 1906), pp. 287–94.

Illustrated with 2 watercolors of the Paved Court and the September Garden by Katharine Montagu Wyatt.

Hussey, Christopher, "Gertrude Jekyll and Philip Webb," *The Life of Sir Edwin Lutyens* (London: Country Life, 1950), pp. 23–35.

Jekyll, Francis, *Gertrude Jekyll: A Memoir* (London: Country Life, 1934), pp. 112, 121–28.

Jekyll, Gertrude, and Lawrence Weaver, "A Garden in West Surrey," *Gardens for Small Country Houses* (London: Country Life, [1912]), pp. 36–45.

Illustrated with 10 photographs, 1 site plan, and 2 detail sketches.

Lorimer, Robert, in Peter Savage, *Lorimer and the Edinburgh Craft Designers* (Edinburgh: Paul Harris, 1980), p. 25.

The Scottish architect Sir Robert Lorimer who was working nearby in Hascombe met Jekyll just after she moved into Munstead Wood and left a lengthy description, which in part reads: "Twenty to thirty acres of a copse across the road, and laid out a complete place there, paths, garden. . . and left a hole in the centre of the ground for the house. . . . It looks so reasonable, so kindly, so perfectly beautiful."

Lutyens, Sir Edwin, in Clayre Percy and Jane Ridley, eds., *The Letters of Edwin Lutyens to His Wife, Lady Emily* (London: Collins, 1985), p. 430.

"Aug.8.33. . .It is sad to see how the garden at Munstead W. has collapsed, but it can't be helped, no Bumps and no longer the 11 essential gardeners."

Lutyens, Robert, *Sir Edwin Lutyens: An Appreciation in Perspective* (London: Country Life Limited, 1942), pp. 28–31.

Lutyens' son, who was an architect, records: "On some occasion at Munstead Wood Miss Jekyll asked father to build her a seat—a massive affair consisting of an immense balk of timber supported on masonry. When it was finished their friend, Charles Liddell, remarked that it looked like the Cenotaph of Sigismunda. . . . Shortly afterwards he jokingly explained to Herbert Jekyll that the new object in the garden was a 'cenotaph for Bumps.'"

Nichols, Rose Standish, "Miss Jekyll's Garden," *English Pleasure Gardens* (New York: The Macmillan Company, 1902), p. 292.

Sackville-West, Vita, in Victoria Glendinning, *Vita: A Biography of Vita Sackville-West* (New York: Alfred A. Knopf, 1983), p. 85.

Vita said, "Miss Jekyll rather fat, and rather grumbly; garden not at its best, but can see it must be lovely" (August 25, 1917).

Tipping, H. Avray, "Munstead Wood," *English Gardens* (London: Country Life, Ltd., 1925), pp. 239–248.

This article, by Country Life's architectural editor, is illustrated with 15 photographs and 1 sketch plan.

Thomas, Graham Stuart, "Foreword," in Gertrude Jekyll, *Colour Schemes for the Flower Garden* (Salem, N.H.: The Ayer Company, 1983), pp. v–xi.

Weaver, Lawrence, "Munstead Wood," *Houses and Gardens by E. L. Lutyens* (London: Country Life, 1913), pp. 12–18.

Illustrated with 10 photographs and 2 plans.

Young, Thomas Frank, in Jane Brown, "Memories of Munstead Wood," *The Garden: Journal of the Royal Horticultural Society*, Vol. 112, Part 4 (April 1987), pp. 162–63.

CAPTION NOTES AND SOURCES

Judith B. Tankard

Unless otherwise specified, the following photographs from the Berkeley photo-notebooks were taken in Gertrude Jekyll's garden at Munstead Wood, Surrey.

Frontispiece. "Cistus by the Wood-Path." Image #1546 (Album 5). Date: early 1900's. Ref: Jekyll, *Colour in the Flower Garden* (1908), p. 17; Jekyll, *A Gardener's Testament* (1937), p. 33.

1. "The House From the Copse." Image #1317 (Album 4). Date: late 1890's. Ref: Jekyll, *Home and Garden* (1900), p. 4; *Country Life*, Vol. 8 (1900), p. 737.

2. (uncaptioned). Image #1432 (Album 4). Date: Spring 1900? Ref: unpublished.

3. "Spring Garden Looking West—Tittlebat." Image #1994 (Album 6). Date: Spring 1907. Ref: Jekyll, *Children and Gardens* (1908), p. 77.

4. "Spring Garden From East End." Image #1992 (Album 6). Date: Spring 1907. Ref: Jekyll, *Colour in the Flower Garden* (1908), p. 27.

5. "Primrose Garden." Image #1502 (Album 5). Date: early 1900's. Ref: *Country Life*, Vol. 8 (1900); Jekyll, *Colour in the Flower Garden* (1908), p. 31; similar views in *The Garden* (22 June 1918), p. 242.

6. "Steps Up From Hidden Garden." Image #1712 (Album 6). Date: c. 1904. Ref: Jekyll, *Colour in the Flower Garden* (1908), p. 32.

7. (uncaptioned). Image #1216 (Album 4). Date: late 1890's. Ref: unpublished. This is one of a group of photographs including #11, #15 and #57 that were probably all taken on the same day and feature Jekyll's housekeeper.

8. "Garland Rose This Side of Hut." Image #2035 (Album 6). Date: Summer 1907. Ref: Jekyll, *Colour in the Flower Garden* (1908), p. 43.

9. "End of Flower-Border." Image #1234 (Album 4). Date: late 1890's. Ref: Jekyll, *Wood and Garden* (1899), p. 210.

10. "East End of South Border." Image #2150 (Album 6). Date: August 1914. Ref: unpublished.

11. "Pathway Across the South Border in July." Image #1214 (Album 4). Date: late 1890's. Ref: Jekyll, *Wood and Garden* (1899), p.202.

12. "South Door." Image #2060 (Album 6). Date: late Summer 1907. Ref: Jekyll, *Colour in the Flower Garden* (1908), p. 51. This photograph is one of four taken at the same time, including #21, #25, and #26, all presumably in August 1907.

13. "End of South Border Looking West. Hydrangeas, Dalhias, Wistaria." Image #2151 (Album 6). Date: "August 14, 1914." Ref: unpublished.

14. "Clematis Montana." Image #1508 (Album 5). Date: early 1900's. Ref: unpublished; similar view in Jekyll, *Wood and Garden* (1899), p. 72.

15. "Hollyhock Pink Beauty." Image #1222 (Album 4). Date: late 1890's. Ref: Jekyll, *Wood and Garden* (1899), p. 105. This early view of the loft building was taken before it was renovated and windows were added, as seen in images of this garden that were published in *Colour in the Flower Garden* in 1908.

16. "Tabby in the Catmint." Image #2080 (Album 6). Date: 1907 or 1908. Ref: unpublished.

17. "September Border Looking Down Through Laburnum Arch." Image #2084 (Album 6). Date: 1907 or 1908. Ref: Jekyll, *Colour in the Flower Garden* (1908), p. 79.

18. "September Borders Looking Down." Image #2085 (Album 6). Date: 1907 or 1908. Ref: Jekyll, *Colour in the Flower Garden* (1908), p. 80.

19. "September Borders Looking Up." Image #2083 (Album 6). Date: 1907 or 1908. Ref: Jekyll, *Colour in the Flower Garden* (1908), p. 92.

20. "Gardener's Cottage." Image #1755 (Album 5). Date: early 1900's. Ref: Jekyll, *Old West Surrey* (1904), p. 42.

21. "AEsculus and Olearia Haastii Looking to House." Image # 2061 (Album 6). Date: August 1907. Ref: Jekyll, *Colour in the Flower Garden* (1908), p. 75; Jekyll and Weaver, *Gardens for Small Country Houses* [1912], fig. 53.

22. (uncaptioned). Image #1327 (Album 4). Date: 1898 or 1899. Ref: unpublished.

23. "Aster Border Looking NW." Image #1986 (Album 6). Date: October 1906. Ref: Jekyll, *Colour in the Flower Garden* (1908), p. 55. This photograph was taken the same month as #50 and #67.

24. "White Lilies and Dwarf Lavender. West End of Three Corners." Image #2142 (Album 6). Date: probably 1914. Ref: unpublished.

25. "Hydrangeas—Tittlebat in Seat. August 27, 1907." Image #2059 (Album 6). Date: "August 27, 1907." Ref: Jekyll, *Colour in the Flower Garden* (1908), p. 124.

26. "Hydrangeas Looking Down Nut Walk." Image #2058 (Album 6). Date: August 1907. Ref: Jekyll, *Colour in the Flower Garden* (1908), p. 124.

27. (uncaptioned). Image #1303 (Album 4). Date: late 1890's. Ref: unpublished.

28. (uncaptioned). Image #1293 (Album 4). Date: late 1890's. Ref: unpublished.

29. "Clematis Montana Trained as Garlands." Image #1881 (Album 5). Date: Summer 1905. Ref: Jekyll, *Colour in the Flower Garden* (1908), p. 106.

30. "Lilium Speciosum, Hydrangea and Funkia." Image #2069 (Album 6). Date: 1907. Ref: Jekyll, *Colour in the Flower Garden* (1908), p. 117.

31. (uncaptioned). Image #1345 (Album 4). Date: 1899. Ref: unpublished. This photograph, as well as #32 and #33, is one of the earliest views of the garden areas adjacent to the house.

32. "Lilies and Cannas in the Tank-Garden." Image #1337 (Album 4). Date: 1899. Ref: Jekyll, *Home and Garden* (1900), p. 77.

33. "This Is an Artesian Well!" Image #1364 (Album 4). Date: 1899. Ref: *Country Life*, Vol. 8 (1900), p. 731; Jekyll, *Children and Gardens* (1908), p. 97.

34. "Francoa by Tank." Image #2066 (Album 6). Date: 1907. Ref: Jekyll, *Colour in the Flower Garden* (1908), p. 116.

35. "Maiden's Wreath (Francoa Ramosa)." Image #1139 (Album 4). Date: late 1890's. Ref: Jekyll, *Colour in the Flower Garden* (1908), p. 113.

36. "The Narrow South Lawn." Image #1935 (Album 5). Date: 1905 or 1906. Ref: Jekyll, *Colour in the Flower Garden* (1908), p. 121.

37. "Lilies and Ferns at the Wood Edge Near Lawn." Image #1936 (Album 5). Date: 1905 or 1906. Ref: Jekyll, *Colour in the Flower Garden* (1908), p. 88.

38. "Ferns and Lilies at a Shrubbery Edge Next the Woods." Image #1934 (Album 5). Date: 1905 or 1906. Ref: Jekyll, *Colour in the Flower Garden* (1908), p. 86.

39. "Gypsophila and Megasea at Shrubbery Edge." Image #1361 (Album 4). Date: 1899. Ref: Jekyll, *Colour in the Flower Garden* (1908), p. 87.

40. "Olearia Gunni, Fern and Funkia at a Shrubbery Edge." Image #1900 (Album 5). Date: 1905 or 1906. Ref: Jekyll, *Colour in the Flower Garden* (1908), p. 85.

41. "Poppies in Trial Garden." Image #858 (Album 3). Date: 1888. Ref: *The Garden* (23 February 1901), p. 127.

42. "White Foxglove and Fern." Image #857 (Album 3). Date: "17 July 1888." Ref: Jekyll, *Wood and Garden* (1899), p. 150; *The Garden* (1 March 1919), p. 92.

43. "Habit Borrowed From a Sussex Monastery on My Gardener, P. Brown." Image #1007 (Album 4). Date: late 1880's or early 1890's. Ref: unpublished; similar photograph in Jekyll, *Wood and Garden* (1899), p. 96, and a smaller, much younger grouping without the gardener appears in *The Garden* (22 September 1888), p. 269.

44. "Workshop—Munstead." Image #275 (Album 2). Date: 1885 or 1886. Ref: unpublished in Jekyll's lifetime. Location: Munstead House.

45. (uncaptioned). Image #100 (Album 1). Date: 1885. Ref: unpublished. Location: unknown.

46. "Large Quilted Curtain Designed and Partly Worked by G.J." Image #399 (Album 2). Date: 1886. Ref: unpublished in Jekyll's lifetime. Location: 43 Hyde Park Gate, London.

47. "Peacock and Orange Trees on Wall by G.J." Image #404 (Album 2). Date: 1886. Ref: unpublished in Jekyll's lifetime. Location: 43 Hyde Park Gate, London.

48. (uncaptioned). Image #257 (Album 2). Date: 1885 or 1886. Ref: unpublished. Location: unknown.

49. "White Dalhia and Clematis Flammula with Seakale and Magnolia Leaves in a Tall Munstead Glass." Image #1951 (Album 5). Date: 1906. Ref: Jekyll, *Flower Decoration in the House* (1907), p. 41. Location: unknown.

50. "Michaelmas Daisies and Hydrangea. October 5, 1906." Image #1984 (Album 6). Date: "October 5, 1906." Ref: Jekyll, *Flower Decoration in the House* (1907), p. 43. Location: unknown.

51. "Munstead Basket." Image #1496 (Album 4). Date: 1899–1901. Ref: unpublished; a line drawing of the basket was advertised in *The Garden* (20 July 1901), p. vi. Location: unknown.

52. "Part of a Patchwork Quilt—Early Nineteenth Century." Image #1697a (Album 5). Date: early 1900's. Ref: Jekyll, *Old West Surrey* (1904), p. 129. Location: unknown.

PHOTOGRAPHIC STUDIES

53. (uncaptioned). Image #14 (Album 1). Date: 1885. Ref: unpublished. Location: unknown.

54. "Garden Gate and Agapanthus—Eastbury." Image #544 (Album 3). Date: 1886. Ref: *The Garden* (30 January 1897), p. 77. Location: Compton, Surrey.

55. "Garden Door—Munstead." Image #259 (Album 2). Date: 1885–86. Ref: Jekyll, *Wood and Garden* (1899), p. 39. Location: Munstead House.

56. "Village Fountain Hascombe." Image #288 (Album 2). Date: 1885–86. Ref: unpublished. Location: Hascombe, Surrey.

57. "Shed Roof. Thatched with Hoop-Chip." Image #1215 (Album 4). Date: late 1890's. Ref: Jekyll, *Wood and Garden* (1899), p. 169. Location: Potting Shed, Munstead Wood.

58. "White Rose on Old Cottage Porch in Busbridge." Image #459 (Album 2). Date: 1886. Ref: *The Garden* (29 January 1887), p. 93; Robinson, *The English Flower Garden* (1889), p. 71; Jekyll, *Wood and Garden* (1899), p. 39. Location: Busbridge village, near Godalming, Surrey.

59. "Stile and Gate Hascombe Road." Image #1834 (Album 5). Date: 1904. Ref: Jekyll, *Old West Surrey* (1904), p. 28. Location: near Hascombe, Surrey.

60. "Garden From Porch—Mr. Hammond Jones. Now Within Tigbourne Court." Image #738 (Album 3). Date: 1887. Ref: *The Garden* (14 January 1888), p. 25; Jekyll, *Wood and Garden* (1899), p. 185. Location: Witley, near Wormley, Surrey.

61. "Wonersh." Image #1844 (Album 5). Date: 1904 or 1905. Ref: unpublished. Location: Wonersh, Surrey.

62. "Weigela Milford House." Image #341 (Album 2). Date: 1885 or 1886. Ref: unpublished. Location: Milford, near Godalming, Surrey.

63. "Enton Mill." Image #1733 (Album 5). Date: c. 1904. Ref: Jekyll, *Old West Surrey* (1904), p. 40. Location: Witley, Surrey.

64. "Entrance Down to Malt House Farm." Image #537 (Album 3). Date: 1886. Ref: Jekyll, *Home and Garden* (1900), p. 46. Location: Hambledon, Surrey.

65. "Cutting Heath-Turf." Image #1819 (Album 5). Date: c. 1904. Ref: Jekyll, *Old West Surrey* (1904), p. 203. Location: probably Munstead Wood.

66. "Heath-Turf-Cutting Tool at Door of Mushroom House." Image #1738 (Album 5). Date: c. 1904. Ref: Jekyll, *Old West Surrey* (1904), p. 202. Location: Munstead Wood.

67. "Gourds. Albert and David Borall. 11 October 1906." Image #1988 (Album 6). Date: "11 October 1906." Ref: Jekyll, *Children and Gardens* (1908), p. 31. Location: Loft building, Munstead Wood.

68. "The Old Bricklayer." Image #1032 (Album 4). Date: late 1890's. Ref: Jekyll, *Old West Surrey* (1904), p. 204. Location: probably Munstead Wood.

69. "Old Cottages." Image #541 (Album 3). Date: 1886. Ref: unpublished. Location: Fittleworth, Sussex.

70. "Wyatt's Almshouses." Image #1810 (Album 5). Date: c. 1904. Ref: unpublished. Location: Wyatt's Close, Farncombe, Surrey.

71. (uncaptioned). Image #67 (Album 1). Date: 1885. Ref: unpublished. Location: unknown.

72. "Beech Unstead Lane." Image #291 (Album 2). Date: 1885 or 1886. Ref: unpublished. Location: lane near Unstead Farm, between Farncombe and Bramley, Surrey.

73. "Copse-Cutter Faggoting Up." Image #1269 (Album 4). Date: late 1890's. Ref: Jekyll, *Old West Surrey* (1904), p. 197. Location: unknown.

74. "Willows Great Tangley." Image #659 (Album 3). Date: 1887. Ref: unpublished. Location: Great Tangley Manor, Wonersh, Surrey.

75. "Oak Roots." Image #1279 (Album 4). Date: late 1890's. Ref: Jekyll, *Home and Garden* (1900), p. 40. Location: unknown.

PORTRAITS

76. "H. B. Brabazon, Leonard Borwick, Dolly Muir MacKenzie (Mrs. Mark Hamburg), with Kitten, Barbara Jekyll (Mrs. Bernard Freyberg), Pamela Jekyll (Mrs. Reginald McKenna). Photographed by G. Jekyll

August 6, 1899." Image #1365a (Album 4). Date: "August 6, 1899." Ref: unpublished in Jekyll's lifetime. Location: Munstead House.

77. "Pamela in Basket." Image #1368 (Album 4). Date: 1899. Ref: *Country Life* (8 December 1900), p. 735; Jekyll, *Children and Gardens* (1908), p. 74. Location: Pamela Jekyll at Munstead Wood.

78. "Pamela and Lilium Auratum—Munstead House." Image #2078 (Album 6). Date: 1907 or 1908. Ref: Jekyll, *Children and Gardens* (1908), p. 30. Location: Pamela Jekyll at Munstead House.

79. "Dorothea Strachey—Rose McFarland." Image #2029 (Album 6). Date: 1907 or 1908. Ref: Jekyll, *Children and Gardens* (1908), p. 76. Location: Munstead Wood.

80. "Tabby." Image #2079 (Album 6). Date: 1907 or 1908. Ref: Jekyll, *Children and Gardens* (1908), frontispiece; in a photo-album Jekyll writes: "Tabby—for more than 12 years my dear companion in house and garden." Location: Munstead Wood.

81. "Dorothea and Dinah at Orchards." Image #2011 (Album 6). Date: 1907 or 1908. Ref: Jekyll, *Children and Gardens* (1908), p. 105. Location: Dorothea Strachey at Orchards, Munstead, Surrey.

82. "Jean and Ann Gibson." Image #2098 (Album 6). Date: 1907 or 1908. Ref: Jekyll, *Children and Gardens* (1908), p. 64. Location: Munstead Wood.

83. "Shoes and Stockings." Image #2095 (Album 6). Date: 1907 or 1908. Ref: Jekyll, *Children and Gardens* (1908), p. 89. Location: Munstead Wood.

NOTES TO TEXT

GERTRUDE JEKYLL'S VISION OF GARDEN AND WOOD

[1] *Country Life*, Vol. 60 (27 November 1926), pp. 805–06

[2] Francis Jekyll, *Gertrude Jekyll: A Memoir* (London: Country Life, 1934), pp. 115–16. This is the only reference that she began photographing in 1885, as the first date that appears in her personal photograph albums is June 7, 1886, for image #427. Album 3 is inscribed "Aug. 3rd/86."

[3] Primrose Arnander.

[4] Album 1 [1885–86], Gertrude Jekyll Collection, Documents Collection, College of Environmental Design, University of California, Berkeley.

[5] See additional notes in Bibliography. For additional information on Country Life, see [Edward Hudson], "Looking Back & Looking Forward: A Letter to the Readers of 'Country Life,'" *Country Life*, Vol. 39 (4 March 1916), pp. 289–93.

[6] "Munstead Wood, Heath Lane, nr. Godalming (The Home of the Late Miss Gertrude Jekyll) by Alfred Savill & Sons, Wednesday & Thursday, 1st & 2nd September, 1948." The two-day sale comprised 673 lots. Courtesy of Primrose Arnander.

[7] See "Report of Progress 1949–1950," p. 5 (published by Reef Point Gardens). Courtesy of Documents Collection, College of Environmental Design, University of California, Berkeley. These photo-notebooks are currently being cataloged by the author for the Documents Collection.

[8] Letter from Beatrix Farrand to Mrs. Robert Woods Bliss, May 21, 1948. Dumbarton Oaks. Courtesy of Diane Kostial McGuire.

[9] The first three albums include almost 900 photographs, all taken in four years, from 1885 to 1888, while the final three albums contain about 1,200 photographs, spanning twenty-five years (1888–1914.)

[10] A longer study on this subject is in preparation by the author.

[11] "Munstead Wood Sketchbook," c. 1892–93. Royal Institute of British Architects Drawings Collection, London. Loan from the Misses Ridley. It consists of thirty pages of sketches, including ones of The Hut and the Gardener's Cottage.

A CONTEMPORARY VIEW OF GERTRUDE JEKYLL'S HERBACEOUS BORDER

The authors wish to thank Michael Tooley, William Howard Adams, and Teni Patterson for their critiques of an earlier version of this essay by Michael Van Valkenburgh in the Autumn 1987 *Design Quarterly*, No. 137 and published jointly by Walker Art Center, Minneapolis, and MIT Press, Cambridge. An additional thank you is extended to Marybeth Flaherty of the Department of Landscape Architecture at Harvard University for her assistance with coordinating the details of this book. The essay was completed while the authors were in residence at the American Academy in Rome in 1988.

[1] Georgina Masson, *Italian Gardens* (New York: Abrams, 1961). John Dixon Hunt, *Garden and Grove. The Italian Renaissance Garden in the English Imagination: 1600–1750* (Princeton: Princeton University Press, 1986).

[2] The word configuration refers to recurring formations in which plants are used in the built landscape, such as an herbaceous border, a parterre, a grove, or a hedge.

[3] This research is being conducted by landscape architect Michael Van Valkenburgh at Harvard University.

[4] Georgina Masson, *Italian Gardens*, pp. 279–88.

[5] Robert Holden, in Sir Geoffrey Jellicoe, et al., eds., *The Oxford Companion to Gardens* (Oxford: Oxford University Press, 1986), p. 186.

[6] Gertrude Jekyll, *Wood and Garden* (Salem, N.H.: The Ayer Co., 1983), p. 264.

[7] Ibid., pp. 264–65.

[8] Keith Thomas, *Man and the Natural World* (New York: Pantheon Books, 1983), p. 226.

[9] Jane Edwards, in Michael Tooley, ed., *Gertrude Jekyll—Artist, Gardener, Craftswoman* (Witton-Le-Wear, England: Michaelmas Books, 1984), p. 27.

[10] Mark Girouard, *Sweetness and Light: The "Queen Anne" Movement 1860–1900* (New Haven: Yale University Press, 1984).

[11] Jane Brown, correspondence with Michael Van Valkenburgh, 22 June 1987.

[12] Michel Chevreul, *The Principles of Harmony and Contrast of Colors and Their Application to the Arts* (New York: Reinhold, 1967).

[13] Among an extensive list of commissions, Lutyens designed the buildings and gardens of the new British capital in New Delhi, India, from 1912 onwards.

[14] See photograph in *Design Quarterly*, No. 137, Autumn 1987.

[15] See photograph in *Design Quarterly*, No. 137, Autumn 1987.

[16] Eleanor McPeck, in Diane McGuire and Lois Fern, eds., *Beatrix Jones Farrand* (Washington, D.C.: Dumbarton Oaks, 1982), p. 26.

[17] Research on the evolution of the planting plans of the Rockefeller Garden is being conducted by landscape architect Patrick Chassé.

[18] As seen in color photographs of this no longer existing garden, circa 1940, provided to Michael Van Valkenburgh by the Gerry family.

[19] See photographs in *Design Quarterly*, No. 137, Autumn 1987.

[20] There have been notable exceptions to the setting aside of the flower by landscape architects in the twentieth century, including the gardens in Brazil by Roberto Burle Marx, such as the Monteiro Garden in Rio de Janeiro; the gardens of Danish landscape architect Carl Sorensen, such as the garden at Hellerup in Copenhagen; and Sir Geoffrey and Susan Jellicoe's paradise garden at Sutton Place in England.

[21] Christopher Tunnard, *Gardens in the Modern Landscape* (London: The Architectural Press, 1938), p. 125.

[22] Ibid., pp. 94–95.

THE SEASONS OF MUNSTEAD WOOD, 1888–1914

[1] See Bibliography for a listing of books and articles by Gertrude Jekyll, as well as a listing of impressions of Munstead Wood by contemporary visitors.

[2] Jekyll wrote over a thousand articles and notes for gardening periodicals, a good number of them illustrated with views of the gardens at Munstead Wood. Her leanest years for magazine-writing were the 1890's, when she was actively laying out her gardens, and the 1900's, when she was writing books. Her most active years were the 1920's, when she provided almost weekly notes with illustrations, suggesting that she not only had the leisure to do so but may also have needed the income to maintain her gardens in a proper style. In 1932, for instance, at age eighty-nine, she wrote about thirty contributions to *Gardening Illustrated*, mostly reworking earlier material.

[3] For these plans, see Gertrude Jekyll Collection, Documents Collection, College of Environmental Design, University of California, Berkeley: File 1, Folder 1. A microfilm of the collection is available in a few libraries and institutions in the United States and England, including Loeb Library, Harvard University Graduate School of Design.

[4] Gertrude Jekyll's nephew Francis Jekyll had access to her diaries when he published his book on his aunt in 1934, but since then they have "disappeared."

[5] Courtesy of Michael Tooley.

[6] Ordnance Survey map SU 9842–9942.

[7] Jekyll, *Home and Garden* (London: Longmans, Green and Co., 1900), p. 1.

[8] Ibid., p. 13. The 1893 plan for the "false start" can be seen in File 1, Folder 1, Item 8 (Documents Collection, College of Environmental Design, University of California, Berkeley) and in Lutyens' "Munstead Wood Sketchbook," Royal Institute of British Architects Drawings Collection, London (hereafter RIBAD). Loan from the Misses Ridley.

[9] Ibid., p. 17.

[10] Probably in 1886. In 1926 she wrote: "The Rhododendrons were planted some years before the house was built, and are now some forty years' growth." *Gardening Illustrated*, Vol. 48 (27 March 1926), pp. 196–97.

[11] Jekyll, "Lawn and Woodland," *Gardening Illustrated*, Vol. 48 (27 March 1926), pp. 196–97.

[12] Jekyll, *Colour in the Flower Garden* (London: Country Life, 1908), p. 13.

[13] Jekyll, "Spring Flowers in a Surrey Garden," *The Garden* (3 May 1919), p. 204

[14] Jekyll, "A Primrose Garden," *Country Life*, Vol. 53 (28 April 1923), pp. 568–69.

[15] *The Garden* (26 August 1882), p. 191.

[16] Helen Allingham's two watercolors of the border (see Bibliography) give an idea of what the color arrangement looked like in Jekyll's time. For a plan in color of the Main Flower Border, see *The Illustrated Gertrude Jekyll* (Boston: Little, Brown and Company, 1988), pp. 76–77.

[17] Jekyll, "The August Borders," *Gardening Illustrated*, Vol. 47 (10 January 1925), p. 25

[18] For a present-day photograph, see the exhibition catalog *Lutyens: The Work of the English Architect Sir Edwin Lutyens (1869–1944)* (London: The Arts Council of Great Britain, 1981), p. 82.

[19] Jekyll, "A Cypress Hedge," *Gardening Illustrated*, Vol. 46 (21 June 1924), p. 375. Jekyll bought the cypresses when they were three feet high for 15s each and planted them three feet apart. By 1924 they were ten feet high by three feet thick and formed a hedge almost 500 feet long.

[20] See Jane Brown's excellent study, *Gardens of a Golden Afternoon* (London: Allen Lane, 1982).

[21] RIBAD, loan from the Misses Ridley. For a reproduction of the

sketch for The Hut, see Margaret Richardson, *The Craft Architects*, RIBA Drawings Series (New York: Rizzoli, 1983), p. 37.

[22] RIBAD.

[23] Documents Collection, College of Environmental Design, University of California, Berkeley, contains eight items on Munstead Wood.

[24] Jekyll and Lawrence Weaver, *Gardens for Small Country Houses* (London: Country Life, [1912]), p. 45.

[25] William Robinson, *The English Flower Garden*, 3rd ed. (London: John Murray, 1893), p. 152.

[26] Jekyll and Weaver, *Gardens for Small Country Houses*, p. 36.

[27] Jekyll, "The Care of Nuts," *Gardening Illustrated*, Vol. 54 (2 April 1932).

[28] On May 27, 1897, Edwin Lutyens wrote to his wife Lady Emily: "We sat cheek by jowl on the Cenotaph to Sigismunda (the seat under the birch tree, so called on account of its monumental simplicity)" (*The Letters of Edwin Lutyens to His Wife, Lady Emily*, edited by Clayre Percy and Jane Ridley, London: Collins, 1985, p. 97). See also Robert Lutyens, *Sir Edwin Lutyens: An Appreciation in Perspective* (London: Country Life Ltd., 1942), pp. 28–31.

[29] Jekyll and Weaver, *Gardens for Small Country Houses*, p. 36.

[30] File 1, Folder 1, Items 2 and 7, Documents Collection, College of Environmental Design, University of California, Berkeley.

[31] Jekyll, *Colour in the Flower Garden*, p. 108.

[32] Jekyll, "Scotch Briars in House and Garden Landscape," *The Garden* (13 July 1901), pp. 30–31.

[33] Jekyll, *Colour in the Flower Garden*, p. 88.

[34] William Robinson, *The Wild Garden* (London: John Murray, 1870).

[35] Jekyll, "Opium Poppy (Papaver Somniferum)," *The Garden* (23 February 1901), p. 127.

[36] Jekyll, "White Foxgloves," *The Garden* (1 March 1919), p. 92.

[37] Fresh-killed rabbits, according to David Pleydell-Bouverie, "Miss Jekyll and I," *House and Garden*, Vol. 160, No 6 (June 1988), p. 111.

INDEX

Judith B. Tankard is an architectural historian who teaches British garden history in the Landscape Design Program at Radcliffe and has lectured in the Professional Development Program at Harvard University.

Michael R. Van Valkenburgh is a landscape architect who is principal of his own design firm in Cambridge and Professor of Landscape Architecture at Harvard University where he teaches design studios and lectures on the design use of plants.

Carol Doyle Van Valkenburgh is an independent filmmaker who lives and works in Boston.

Jane Brown is the author of five books on 20th-century gardeners and garden design, including *Gardens of a Golden Afternoon*; the story of the partnership between Edwin Lutyens and Gertrude Jekyll.